TO YOU

THE PEOPLE OF NEW YORK

FOREWORD

Persons looking on Weegee's incredible photographs for the first time find it hard to believe that one ordinary earth-bound human being could have been present at so many climactic moments in the city's life.

The simplest explanation of the phenomenon is that true love endows a man with superhuman qualities, and Weegee is truly in love with New York. Not the New York that you and I know, but the New York that he has known, first as a poor immigrant boy and later as a free-lance newspaper photographer specializing in crime and violence.

Loving the city, Weegee has been able to live with her in the utmost intimacy. When he goes to bed in his room across the street from police headquarters, the city murmurs to him from the police-approved shortwave radio beside his bed. Even in slumber he is responsive to her. He will sleep through fifteen unpromising police calls and leap out of bed at the promising sixteenth. In sickness and in health he will take his camera and ride off in search of new evidence that his city, even in her most drunken and disorderly and pathetic moments, is beautiful. Of course Weegee, being an Artist, has his own conception of what constitutes beauty, and in some cases it is hard for us to share his conception; but insofar as we can share it, we can share his love for the city.

When he cruises in his 1938 Chevrolet, his love is beside him, talking to him from another shortwave radio; and as he

listens to her he is also watching her, and he will stop to photograph the drunk asleep in front of the funeral parlor as further evidence of his love's infinite variety.

Weegee is a rather portly, cigar-smoking, irregularly shaven man who has seen and recorded a great deal of ugliness and disaster, but he remains as shy and sensitive as if he had spent his life photographing babies and bridesmaids. This, I think, is further evidence that he has been inspired not by a taste for sensationalism but by his love for the city and her children—especially the troubled and unfortunate ones, the kitten-loving ones who sleep on fire escapes in the summer.

I think that Weegee's subjective portrait of New York must be regarded as a work of creative art, because, although all of the elements were there for anyone to use, no one has ever used them as Weegee has. This portrait lived first in Weegee's heart and imagination. He patiently sought and painstakingly assembled those elements in a manner that would make it possible for us to see his city and believe it, and love it—and yet want to make it better. You don't want those kids to go on sleeping on that fire escape forever, do you?

William McCleery
New York
Editor, PM *Picture News*

CONTENTS

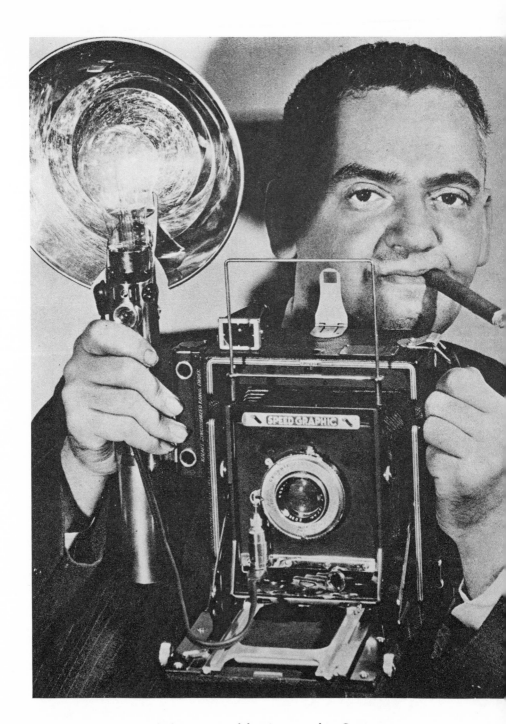

Weegee and his Love — his Camera

A BOOK IS BORN

One just doesn't go up to strange men, women, children, elephants, or giraffes and say, "Look this way please. Laugh—cry—show some emotion or go to sleep underneath a funeral canopy." They would have called me crazy and called a cop who would have called the wagon with the guys in white and I would have wound up in the psychopathic ward at Bellevue Hospital in a strait jacket.

For the pictures in this book I was on the scene; sometimes drawn there by some power I can't explain, and I caught the New Yorkers with their masks off . . . not afraid to Laugh, Cry, or make Love. What I felt I photographed, laughing and crying with them.

I have been told that my pictures should be in a book, that they were a great social document. As I keep to myself, belong to no group, like to be left alone with no axe to grind, I wouldn't know. Then something happened. There was a sudden drop in Murders and Fires (my two best sellers, my bread and butter). I couldn't understand that. With so many millions of people, it just wasn't normal, but it did give me a chance to look over the pictures I had been accumulating. Put together, they seemed to form a pattern. I pasted the photographs up into a "dummy" book and left it with the publishers with a note "This is my brain child . . . handle with care please."

The people in these photographs are real. Some from the

East Side and Harlem tenements, others are from Park Avenue. In most cases, they weren't even aware they were being photographed and cared less. People like to be photographed and will always ask "What paper are you from, mister, and what day will they appear," the jitterbugs and the Sinatra bobby-sock fans even want to know on what page it will appear. To me a photograph is a page from life, and that being the case, it must be real.

WEEGEE'S NAKED CITY

1 SUNDAY MORNING IN MANHATTAN

This is the most peaceful time of the whole week. Everything is so quiet . . . no traffic noises . . . and no crime either. People are just too exhausted for anything. The Sunday papers, all bundled up, are thrown on the sidewalk in front of the still-closed candy stores and newspaper stands. New Yorkers like their Sunday papers, especially the lonely men and women who live in furnished rooms. They leave early to get the papers . . . they get two. One of the standard-size papers, either the *Times* or *Tribune* . . . they're thick and heavy, plenty of reading in them, and then also the tabloid *Mirror* . . . to read Winchell and learn all about Cafe Society and the Broadway playboys and their Glamour Girl Friends. Then back to the room . . . to read and read . . . to drive away loneliness . . . but one tires of reading. One wants someone to talk to, to argue with, and yes, someone to make love to. How about a movie — NO — too damn much talking on the screen. "But Darling I do love you . . . RAHLLY I do,". . . then the final clinch with the lovers in each other's arms . . . then it's even worse, to go back alone to the furnished room . . . to look up at the ceiling and cry oneself to sleep.

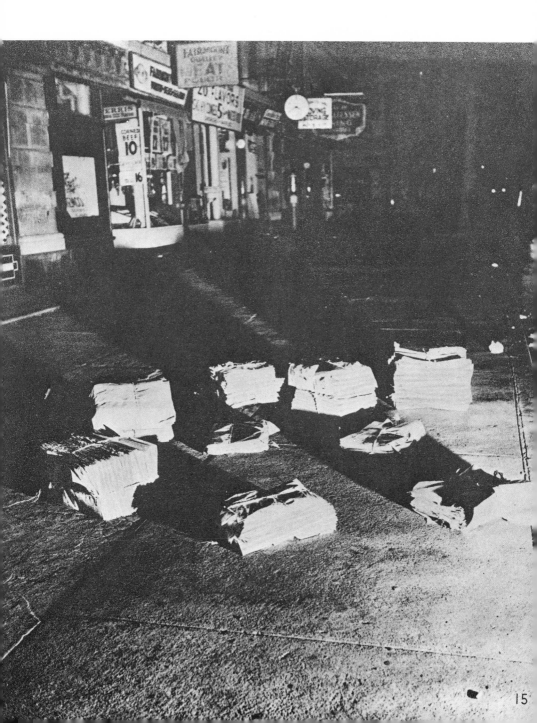

15

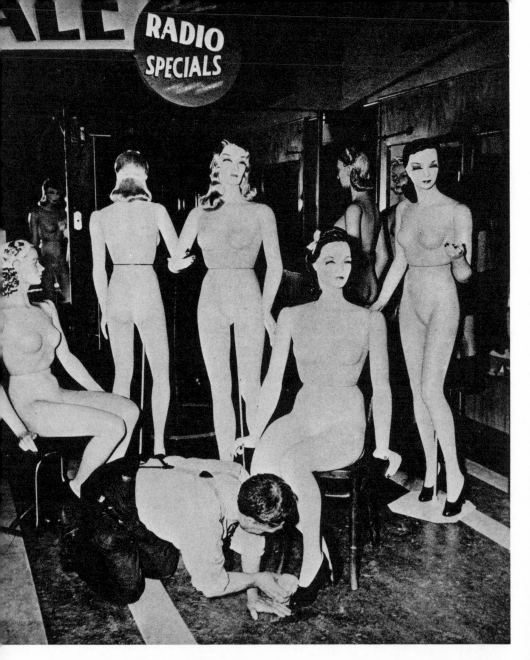

Sunday morning is the only time these cuties get a chance to get cleaned up . . . while the store is closed . . . they are taken out from the store window . . . their garments with price tags removed . . . and given a thorough scrubbing . . . the mannequins are patterned after the current Hollywood movie glamour stars . . . and are worth their weight in gold, each one costing a few hundred dollars.

16

... Even F.D.R. too —

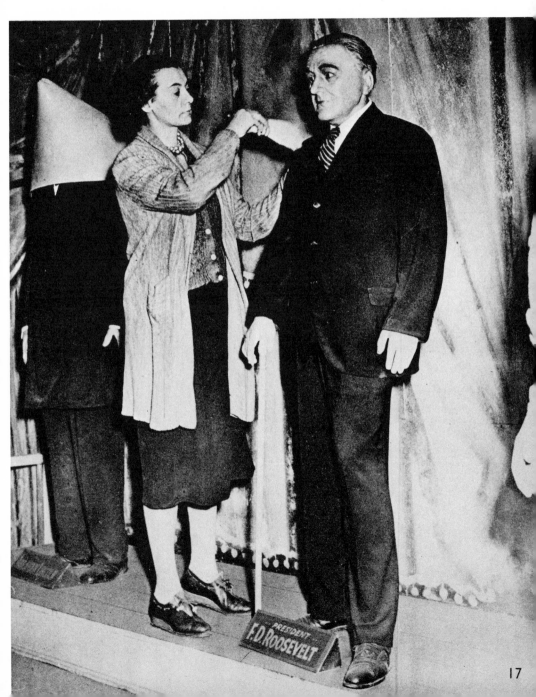

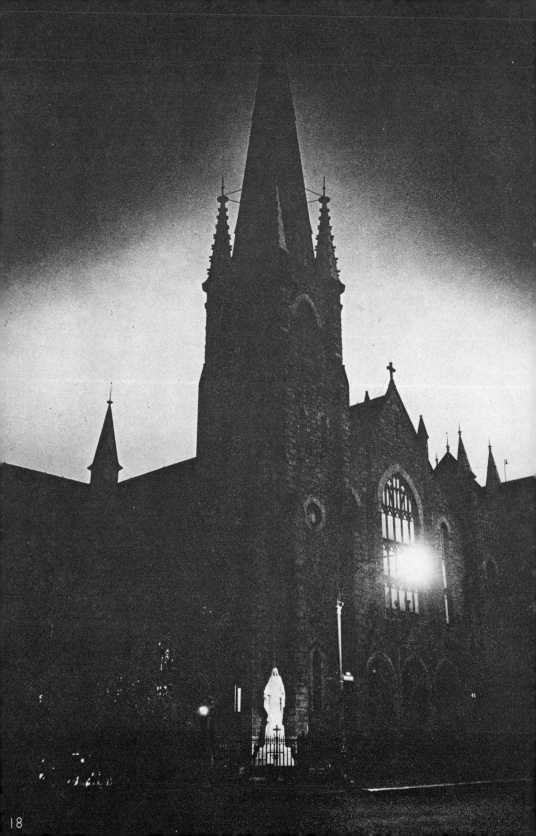

18

It is now almost six in the morning ... it is still dark ... but the church is open ... and the early morning worshippers find solace inside ... except for this tired Sunday traveler who, a few blocks away, finds a resting place underneath the canopy at number 711 Amsterdam Avenue ... This avenue is full of saloons, and they are called just that ... no fancy foreign names like Cocktail Lounges ... So sleep on stranger ... no one will bother you ... not even the cops ... Sunday is a good day for sleeping — so is any other day — when one is tired.

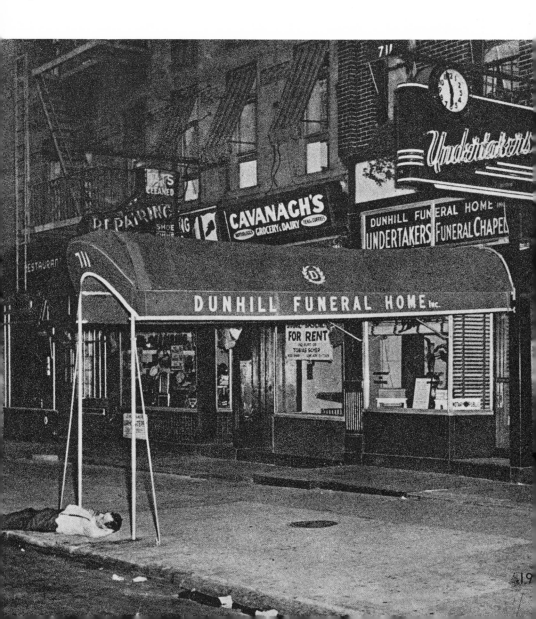

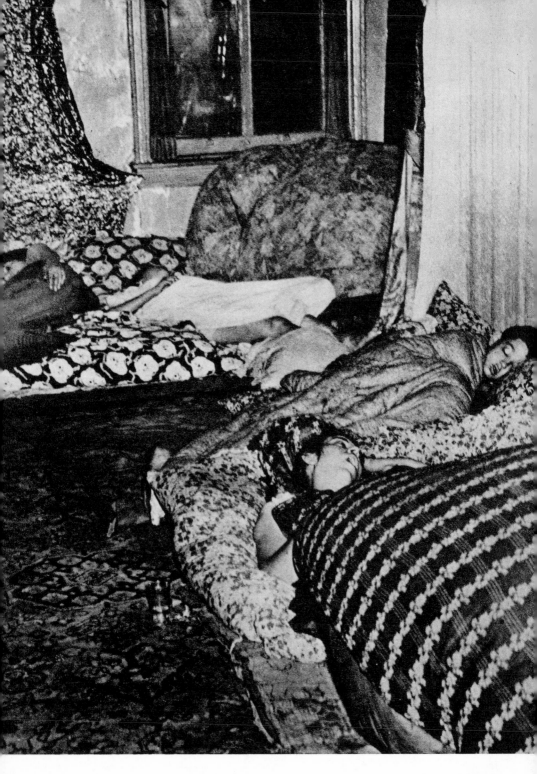

Sleep

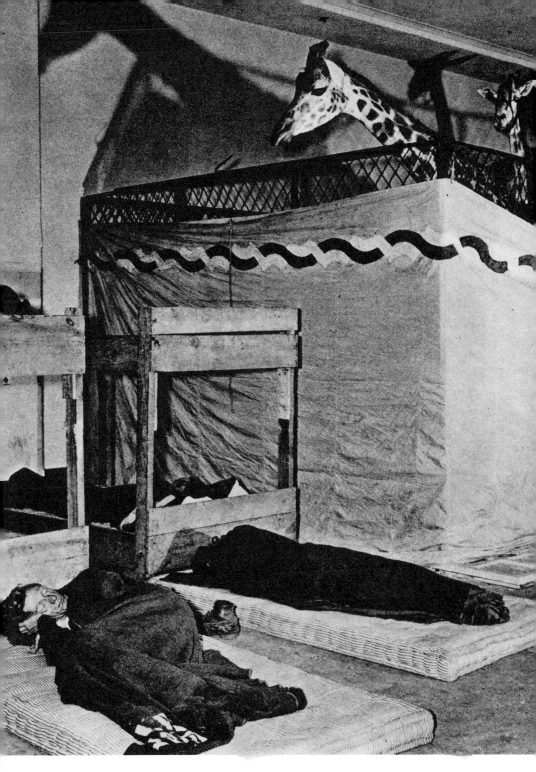

. . . is where you find it.

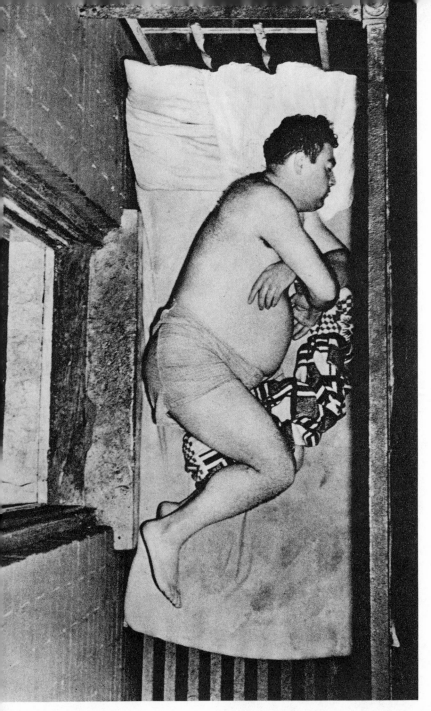

TENEMENT
PENT-
HOUSE

But the other fire escape is somewhat overcrowded . . . it's not so bad sleeping that way . . . except when it starts to rain . . . then back to the stuffy tenement rooms.

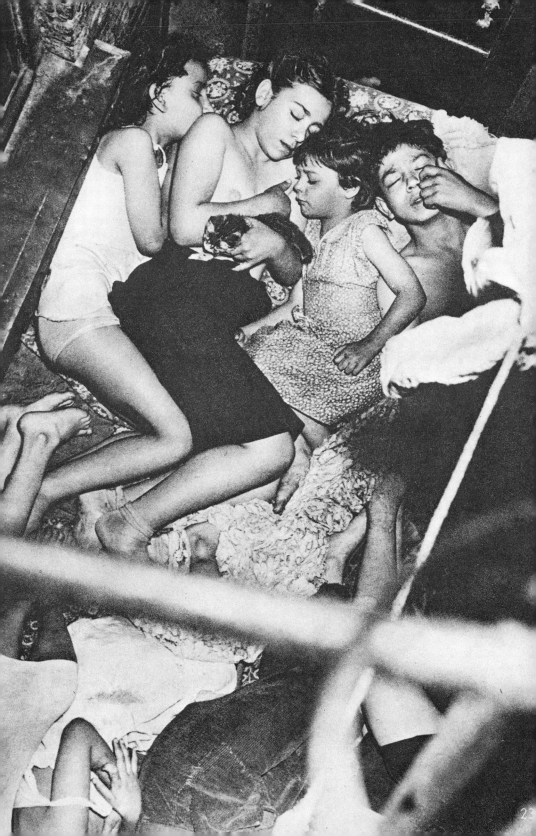

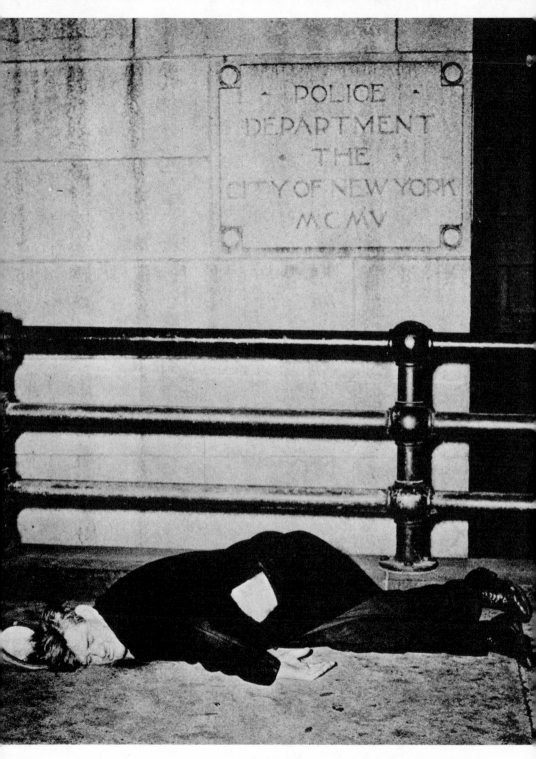

HEY!... The Cops won't like this...

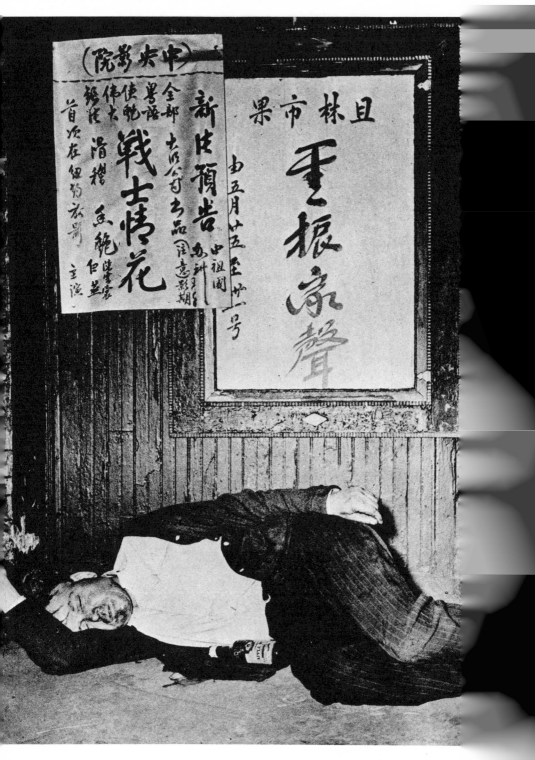

— Or this.

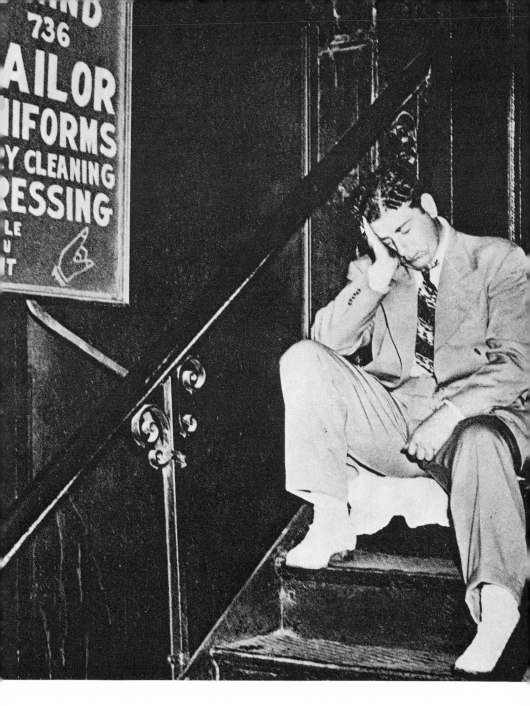

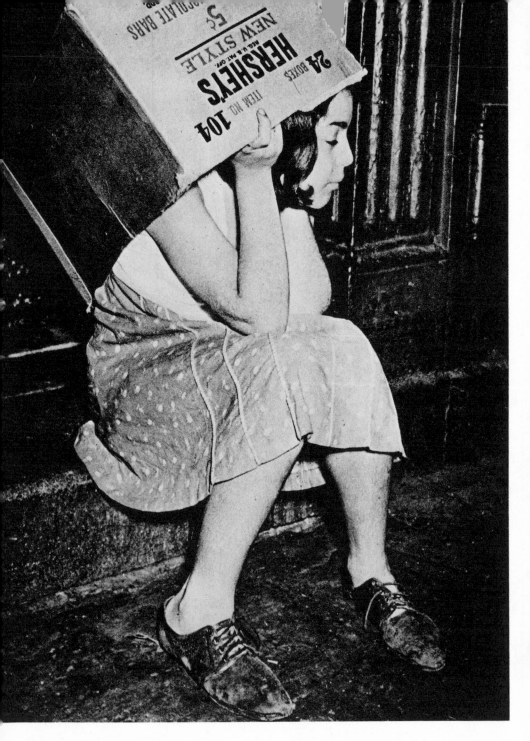

Little girl . . . what are you doing out at three in the morning . . . you should be home asleep.

Pleasant sleep . . . darling.

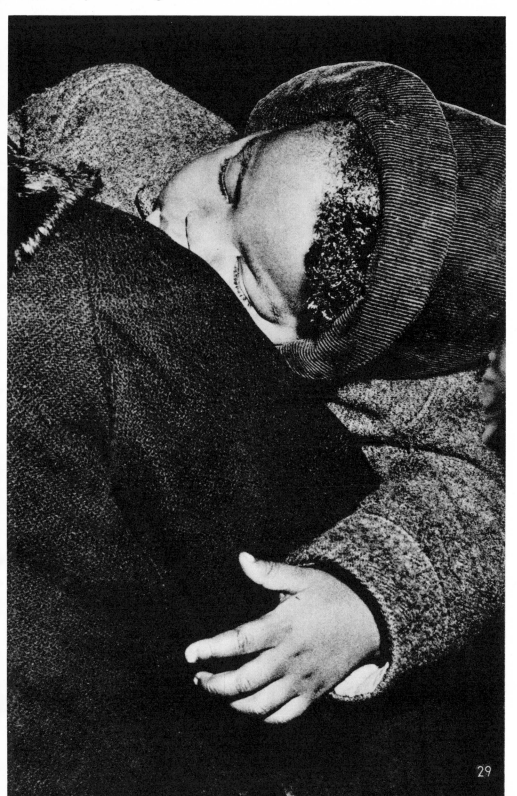

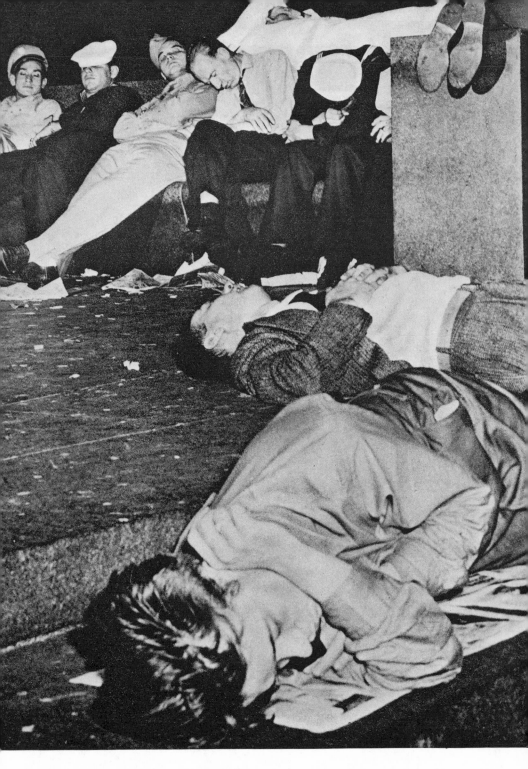

Open Air Canteen Broadway and 47th Street at five in the morning.

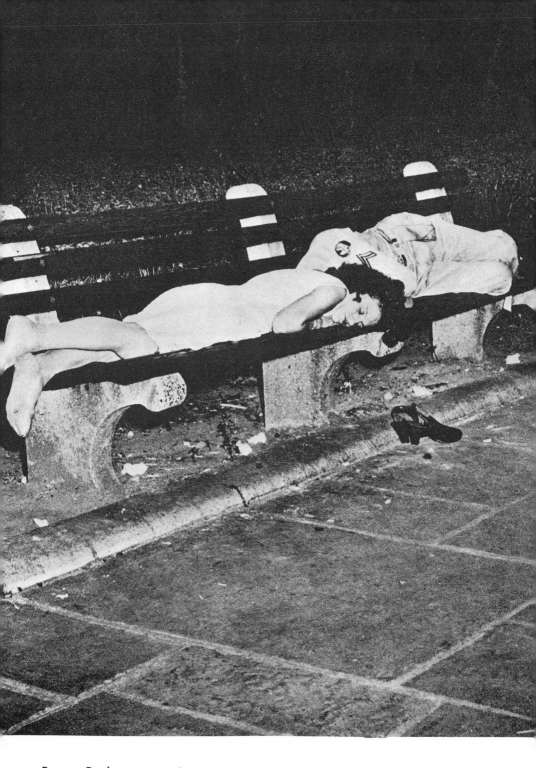

Bryant Park . . . same time.

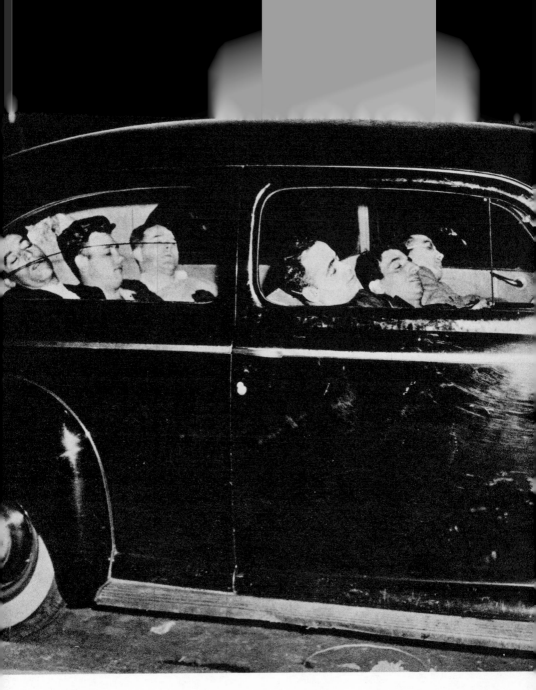

Is this an epidemic? . . . Everybody is doing it.

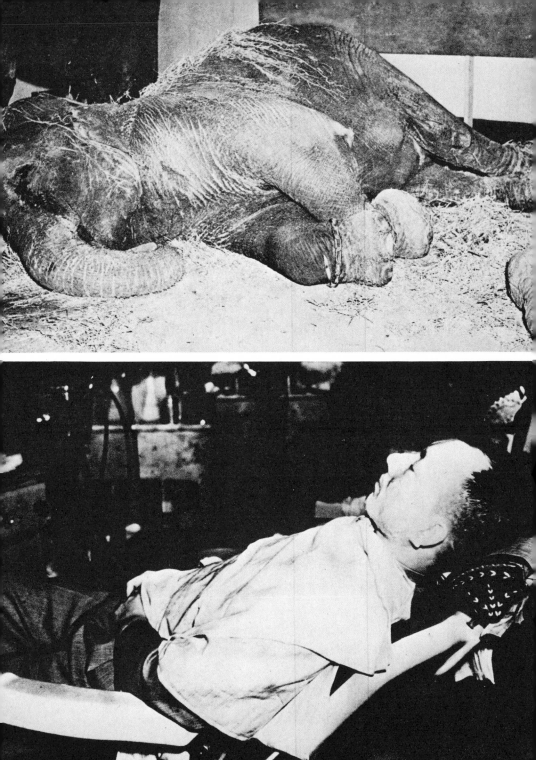

33

2 THE CURIOUS ONES...

These are the men, women, and children on the sidewalks of New York . . . always rushing by . . . as if life itself depended on their reaching their destination . . . but always finding time to stop and look at a fire . . . murder . . . a woman about to jump off a ledge . . . also to look at the latest news flashes on the electric sign on the Times Building in Times Square . . . the latest baseball results pasted in windows of stores . . . and to listen to music coming out of phonograph stores.

They always want to know what paper I'm from and if the person is dead. They seem to be disappointed if they see a sign of life as the stretcher with the injured is carried before them.

The cops have their hands full at fires with the spectators, and have to watch out that they don't get injured by falling debris . . . high pressure hose lines breaking, etc.

When they have had their fill of the scene, they disappear as quickly as they came . . . in a terrific hurry. . . .

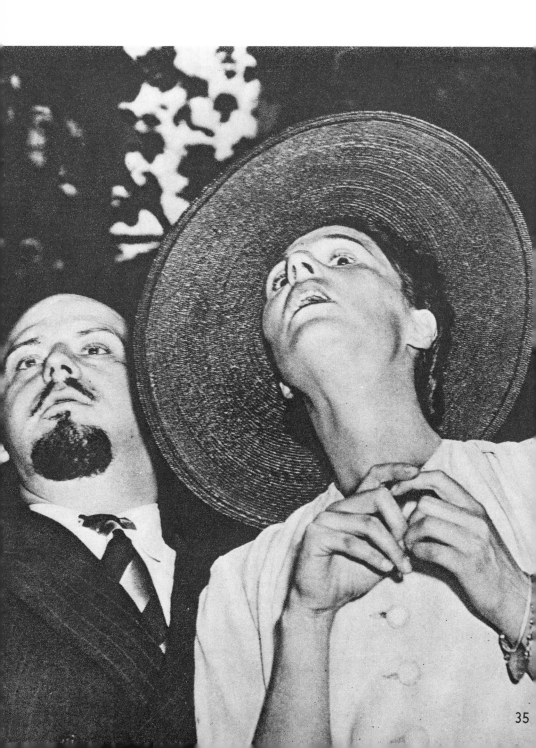

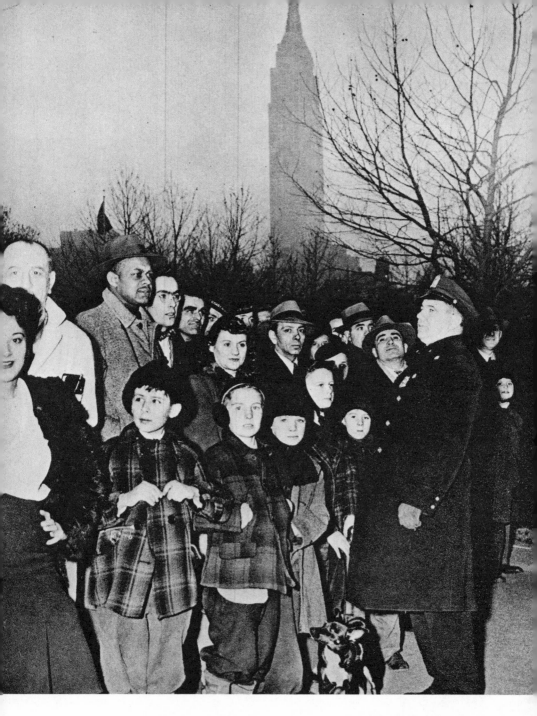

Afternoon . . . they are watching me take their picture . . . and also a fire.

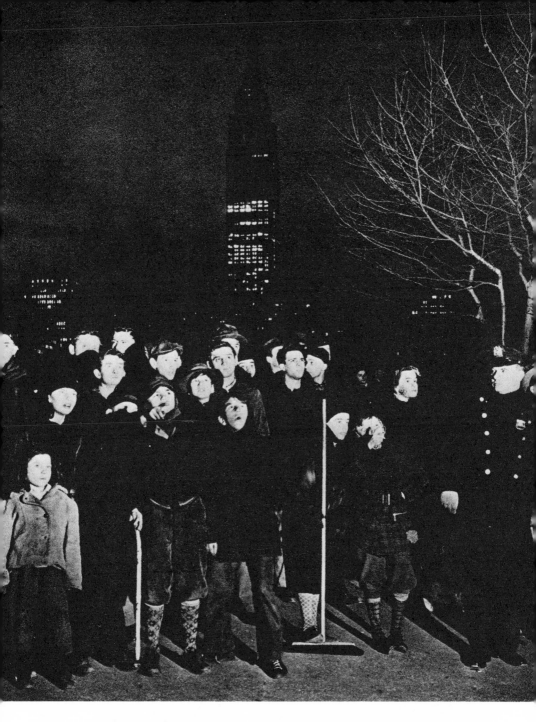

Night . . . a black velvet curtain has dropped over the white sky . . . a few mothers went looking for their kids . . . found them here . . . dragged them home for supper . . . but they are back again . . . but that's the same Empire State Building in the Background. . . .

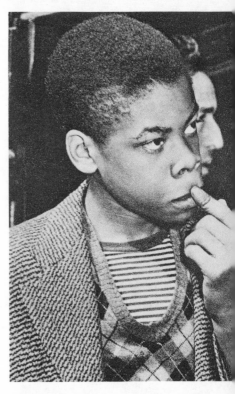
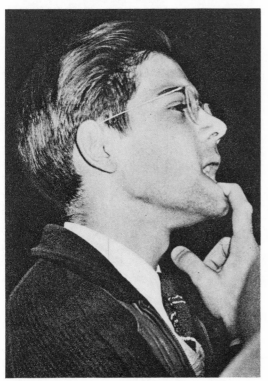
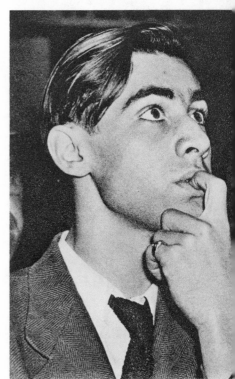

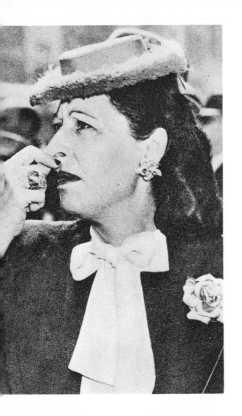
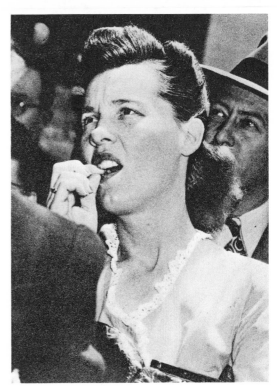
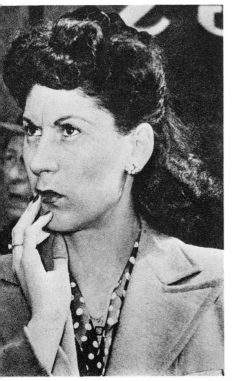
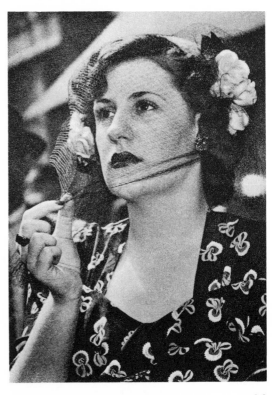

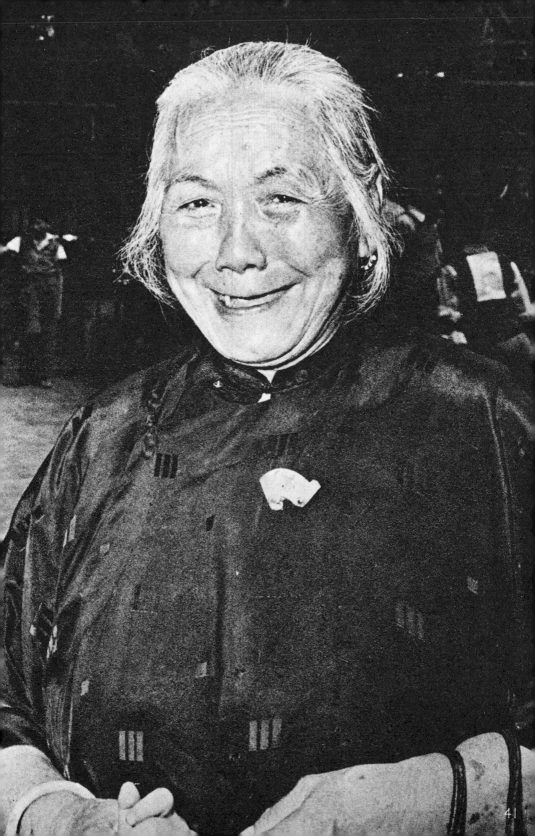

41

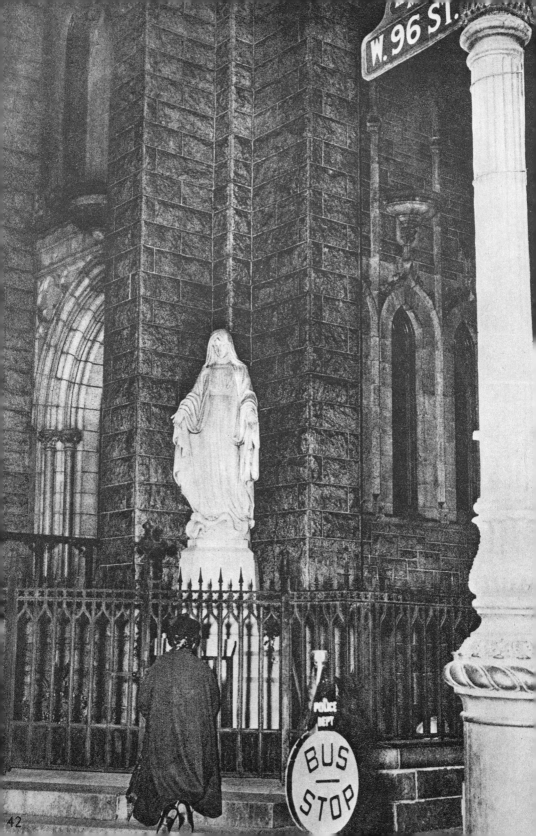

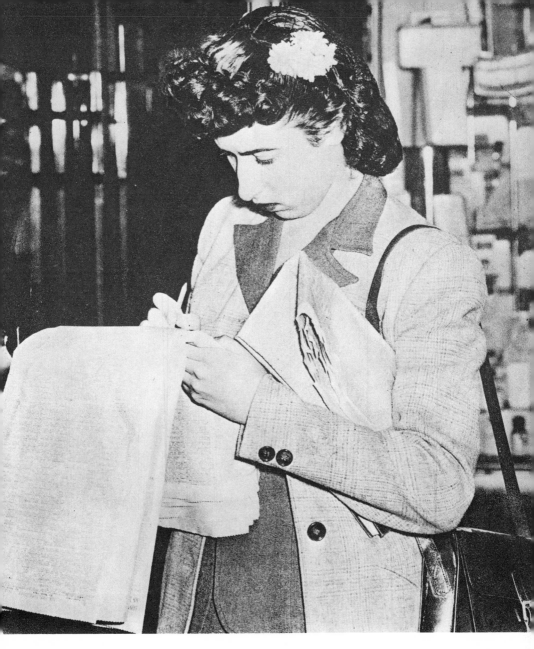

One woman kneels at the still-closed church on the way to work, while another girl checks off jobs in the help-wanted section of the *New York Times*.

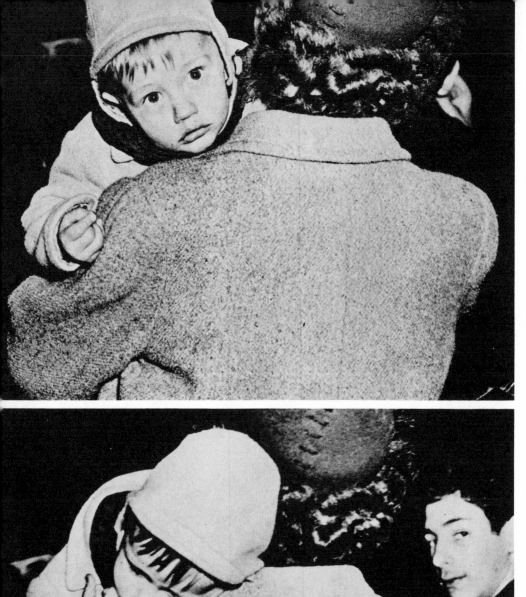

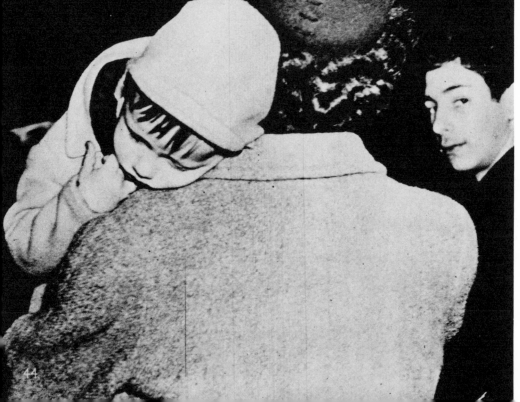

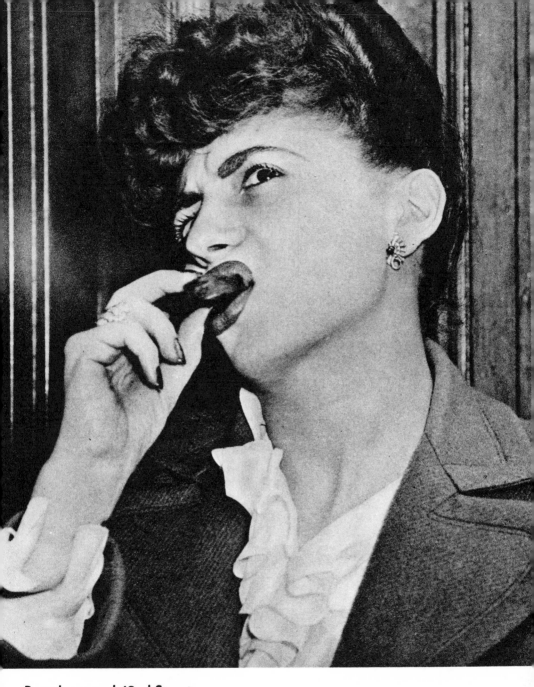

Broadway and 42nd Street

Mother stopped to read the flashes of the latest news on the **Times Building**
. . . but baby wasn't curious about that, and fell asleep . . . but the girl was
interested as she ate an eskimo pie.

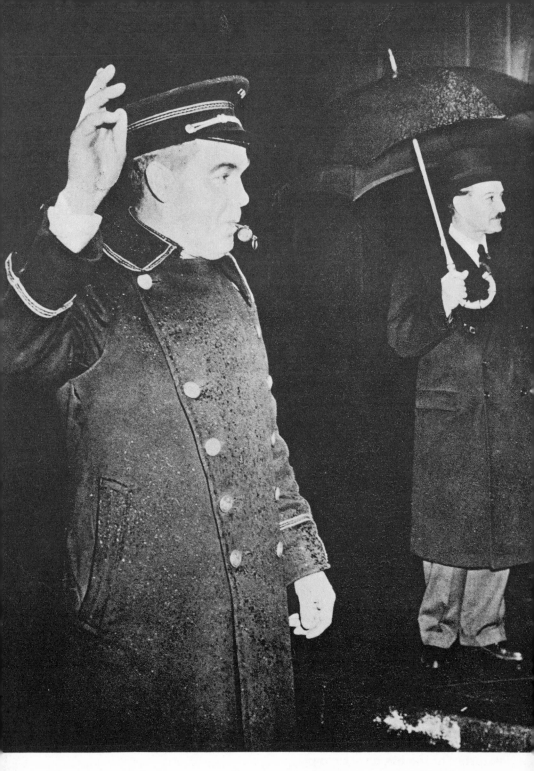

Doorman is signalling for a taxi.

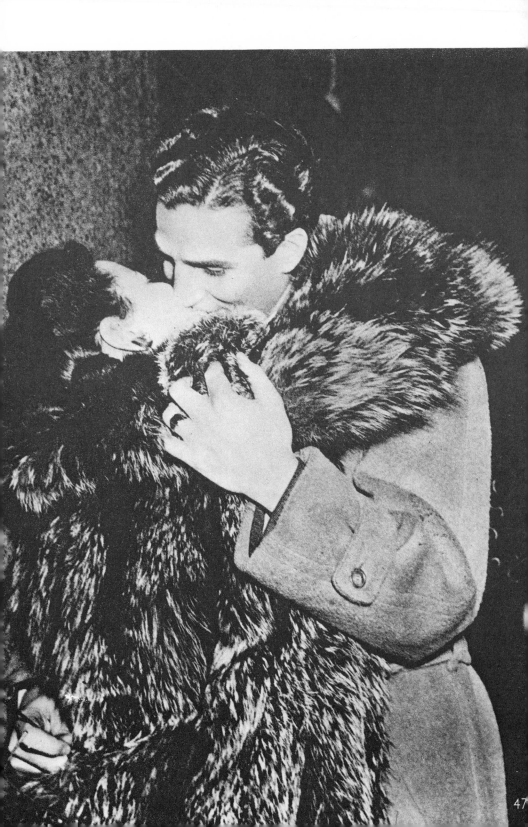

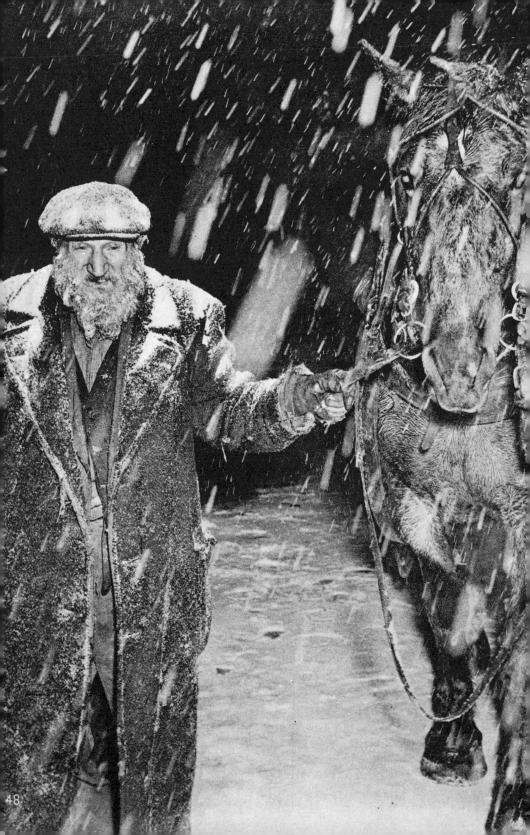

49

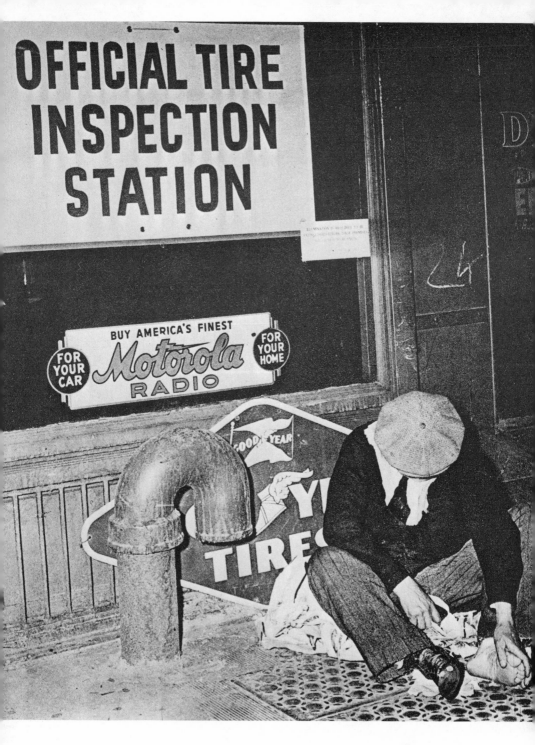

"Tired" Inspection

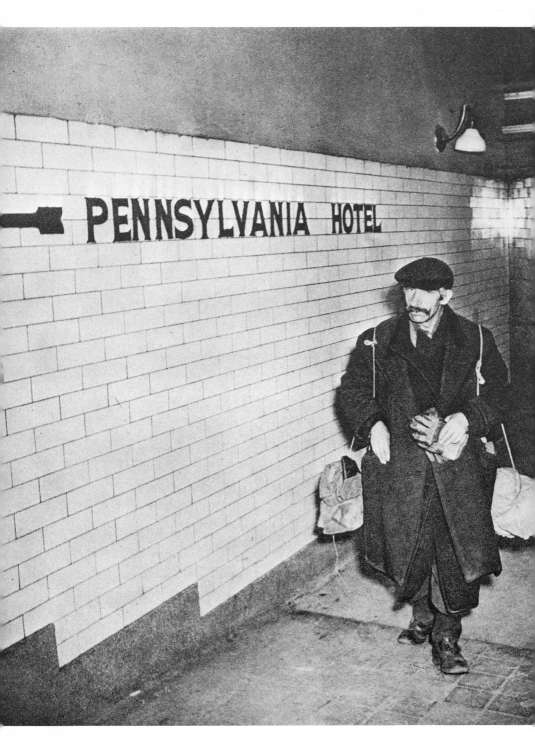

This homeless man in the subway station . . . I wonder where he is going to "flop."

3 FIRES...

The surprising thing about New York families, living as they do in such crowded conditions, is that they still manage to crowd in pets like dogs, cats, parrots, which they always try to save at fires. At one fire, I saw a woman running out holding a cardboard box with a couple of snakes inside. I questioned her. (It was none of my business, but I'm curious about people) . . . she told me she was a dancer who used the snakes in her act.

At fires in which persons are burned to death . . . the bodies are brought out wrapped in canvass bags . . . by firemen . . . while a police radio car will go to the nearest church, wake up the priest, who will rush to the scene in the cop's radio car and give the last rites. This always makes me cry . . . but what can I do . . . taking pictures is my job . . . and besides I'd rather take a picture of someone being rescued alive . . . it makes a better picture.

At fires I also make shots of the crowds watching the fires . . . for the detectives and fire marshals who are always on the scene . . . on the look out for pyromaniacs . . . jealous lovers . . . thrill seekers . . . disappointed would-be firemen . . . who having failed in their examinations will start fires. . . . Also at fires where there are rescues . . . different firemen will take credit for such rescues . . . my photos decide who did make the rescue and end all disputes.

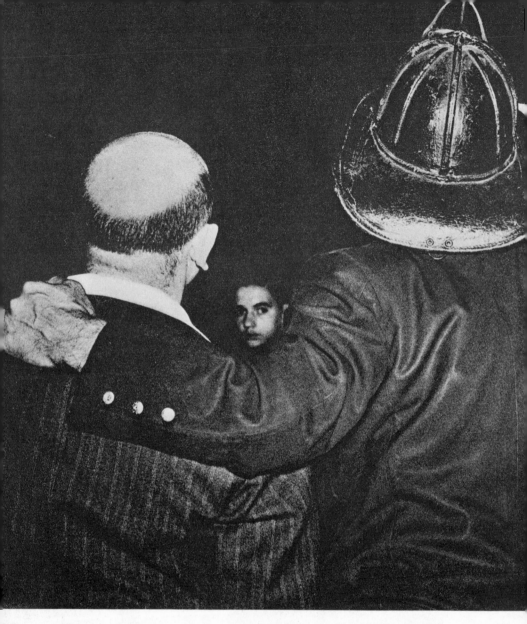

This is risky, tricky work . . . especially at five in the morning . . . when one is suffocating from smoke. Then a fireman grabs you and the slow tortuous journey down the 85 foot aerial rescue ladder. It seems hours up there in the swaying ladder before one actually reaches the street . . . but really it only takes a few minutes. The fireman guides you down gently, telling you not to worry . . . it is dark.

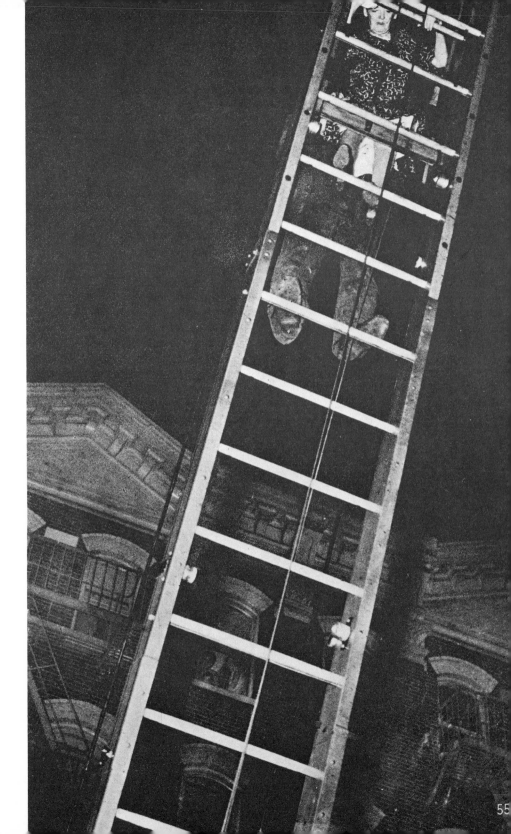

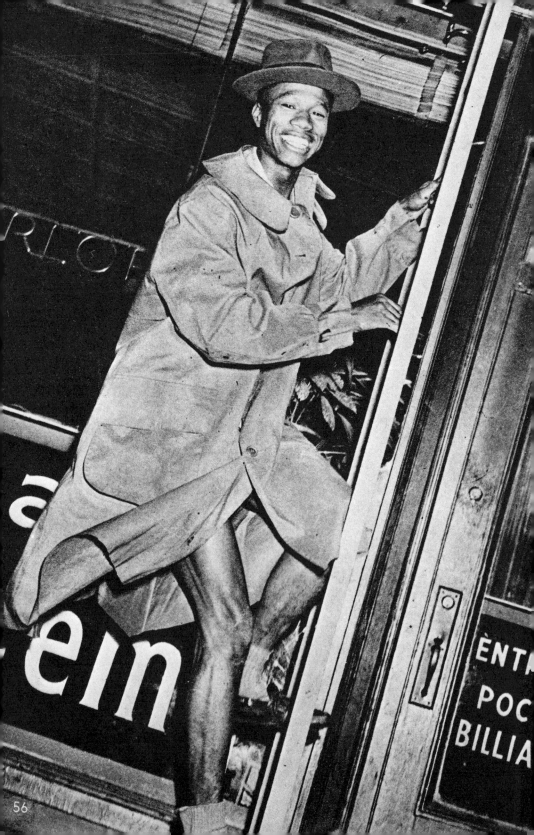

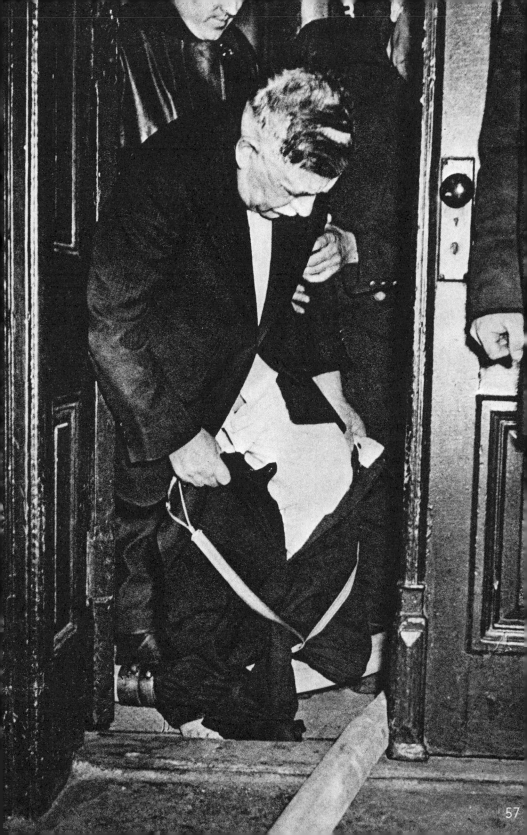

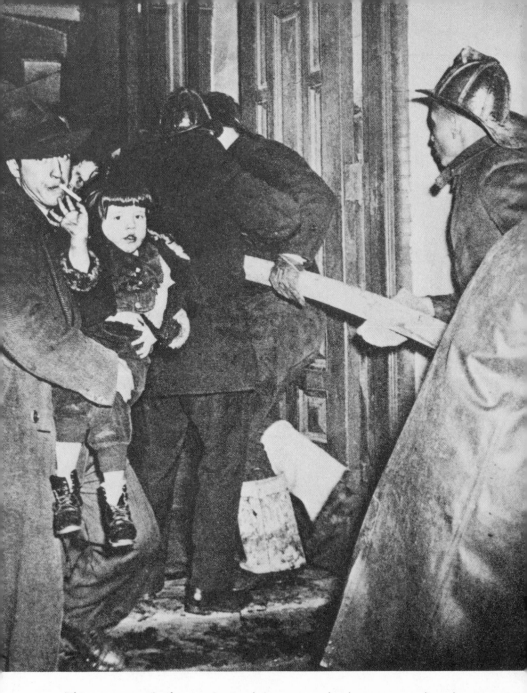

This man was lucky . . . he hadn't gone to bed as yet . . . but the rooms got full of smoke . . . the lights went out . . . so he grabbed his kid . . . without tying the kid's shoelaces . . . and ran for his life. He is surprised to find me there with my camera. He must wonder if my studio is on the fire engine . . . and if I sleep in the Fire House.

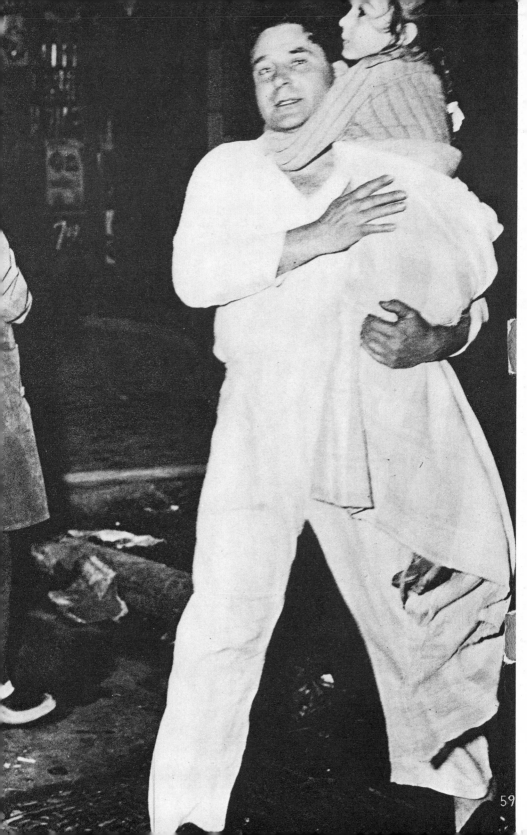

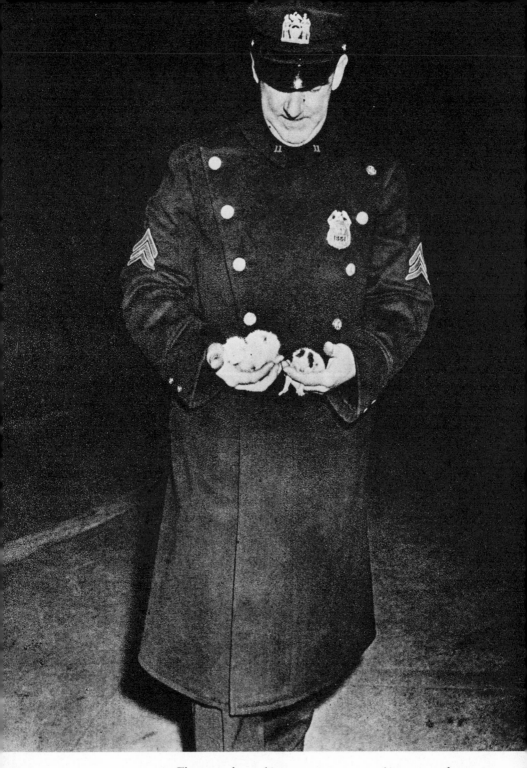

The new-born kittens were rescued too . . . of course.

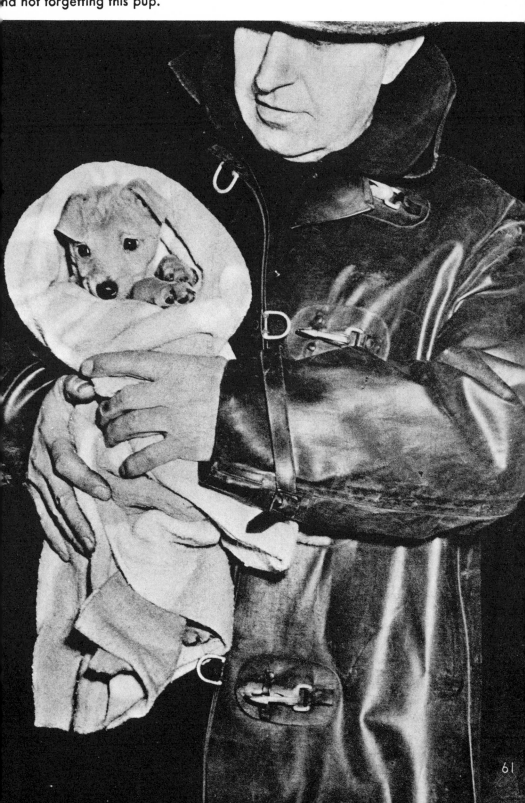

61

This girl was happy. Not only was she rescued, but her precious violin too.

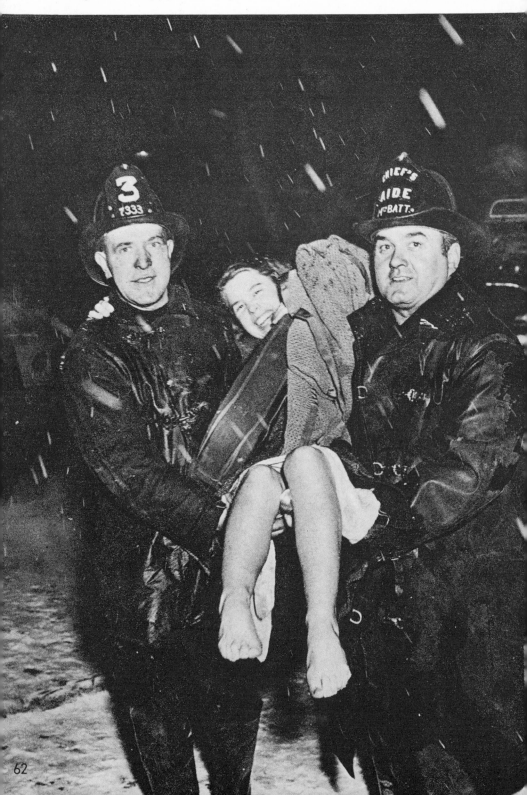

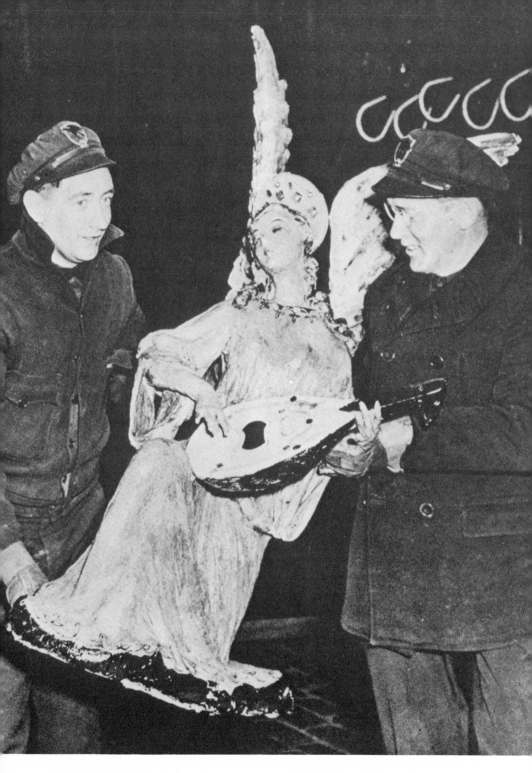

. . . And an Angel too.

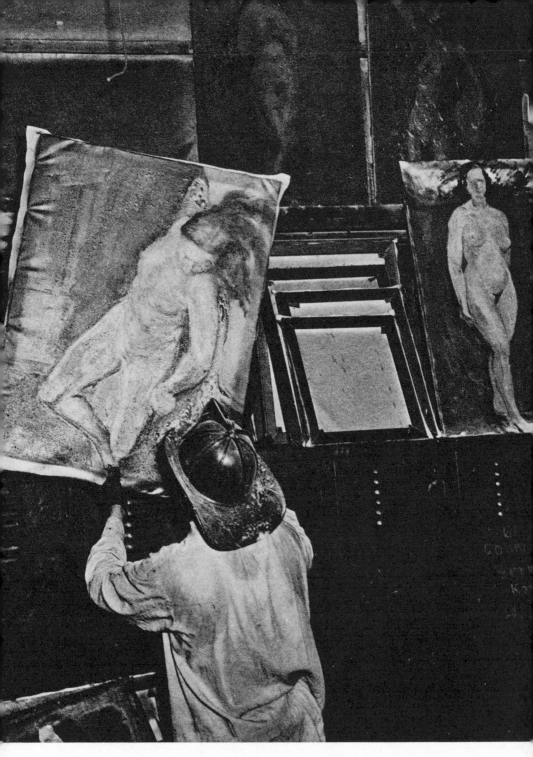

One never knows what there will be in a New York apartment house . . . th
paintings were saved in an artist's studio. . . .

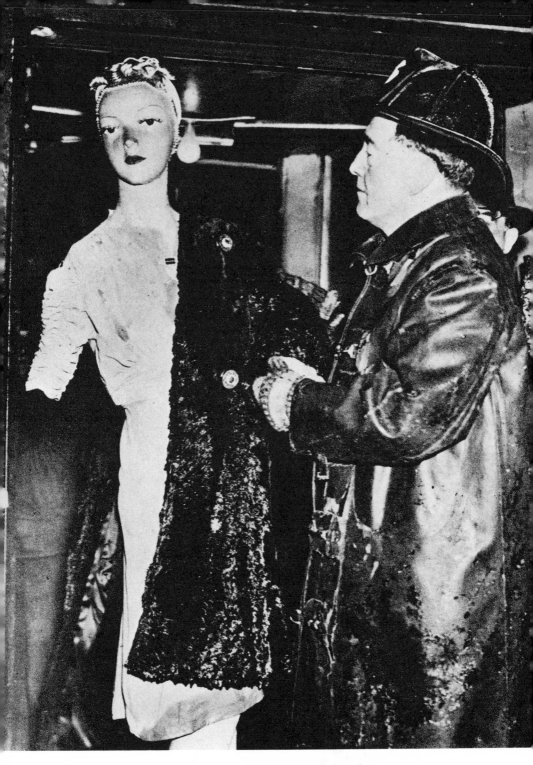

— and a dummy in a dressmaker's shop.

Someone rushed in and saved the Torah (Holy Scroll) from the synagogue ... strange at fires holy objects seem to be immune to flames ... God must watch over them.

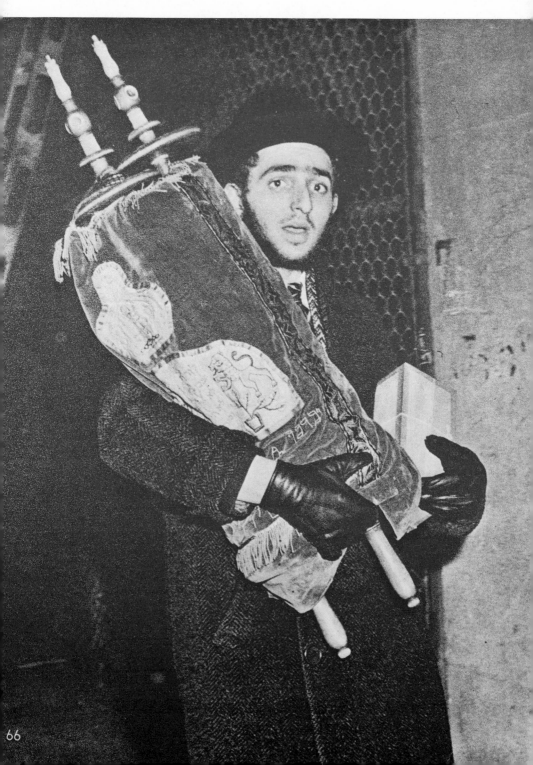

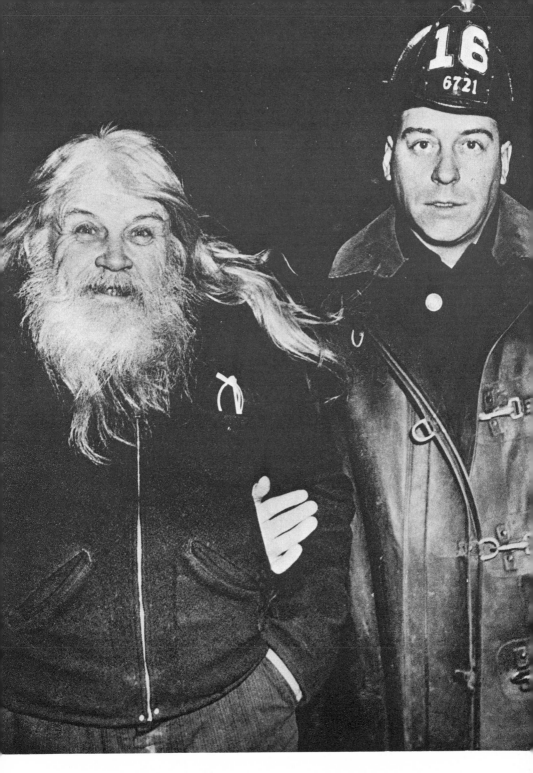

A department store Santa Claus was saved . . . including his whiskers.

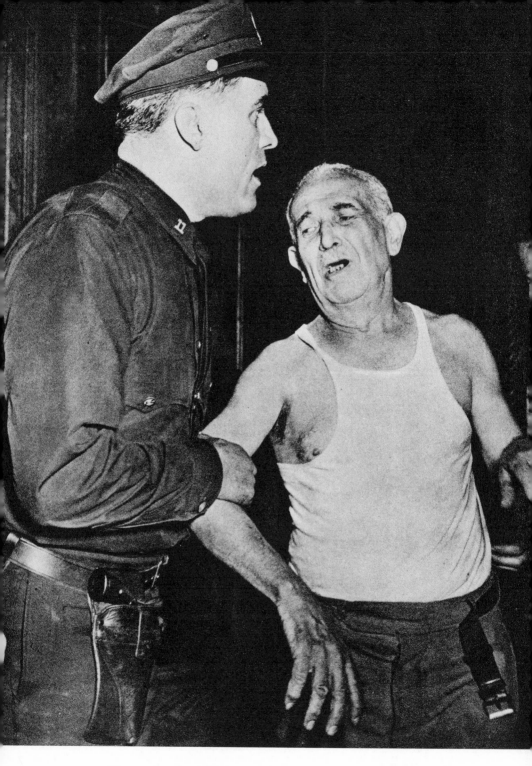

The crying landlord . . . because his property was damaged

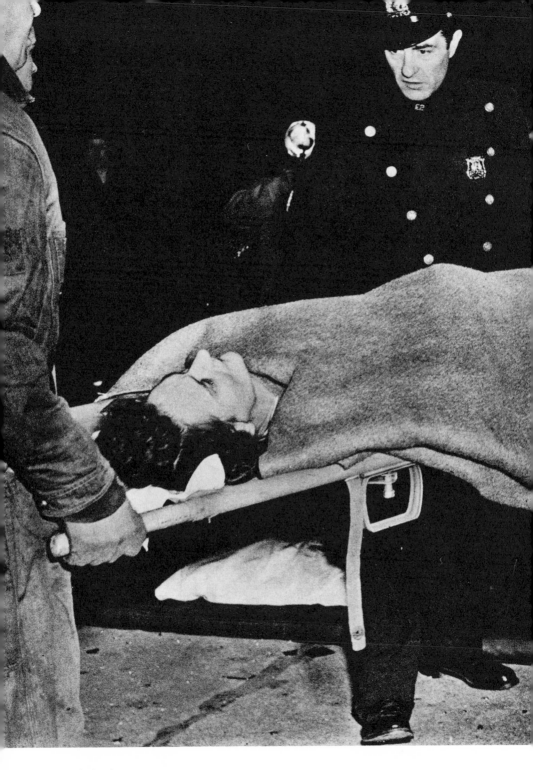

. . . and the human cop.

Not waiting for the movie theatre to open . . . but a refugee from a fire . . . waiting so the firemen will let her get back into her tenement flat . . . as soon as it's safe.

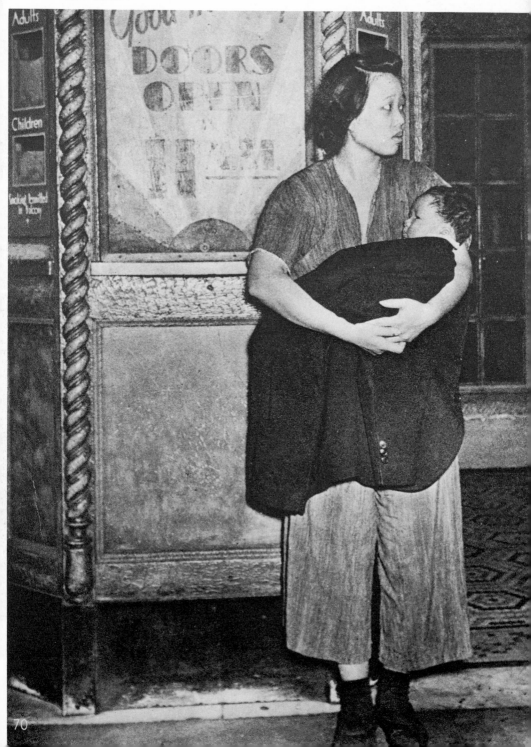

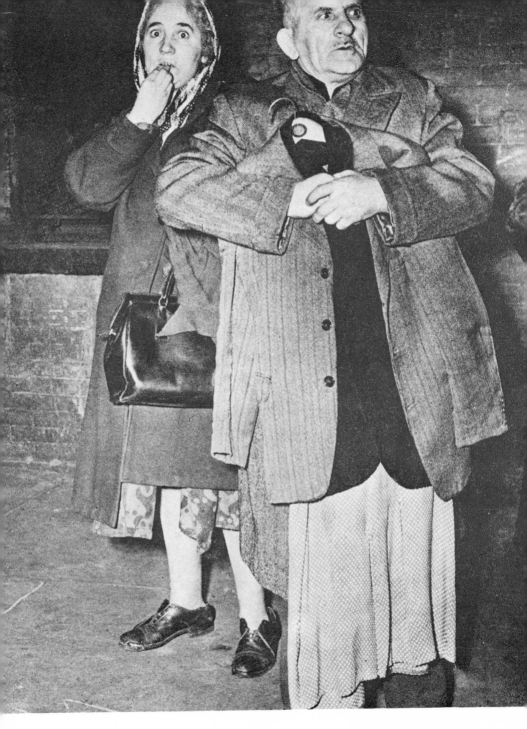

A couple driven out from the burning tenement . . . I don't know their names . . . but I did hear someone call him "Pincus" . . . so here they are right across the street from their burning tenement . . . it looks like Pincus had time to grab a woman's dress . . . his best coat . . . but minus the pants.

71

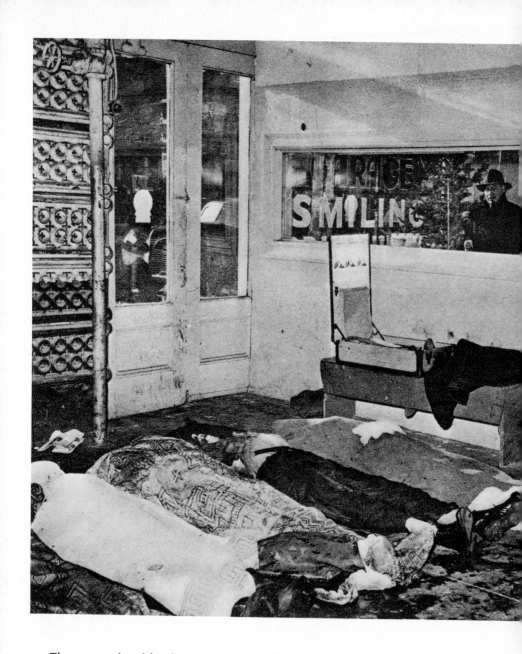

These are dead bodies . . . wrapped by firemen in "bodybags." The priest
is giving the last rites to all that's left of a mother and her two babies . . .
besides the firemen . . . there are no spectators . . . it's early morning . . .
people are rushing to work . . . and can't stop to look . . . they'd be late . . .
and the boss will holler like hell. . . .

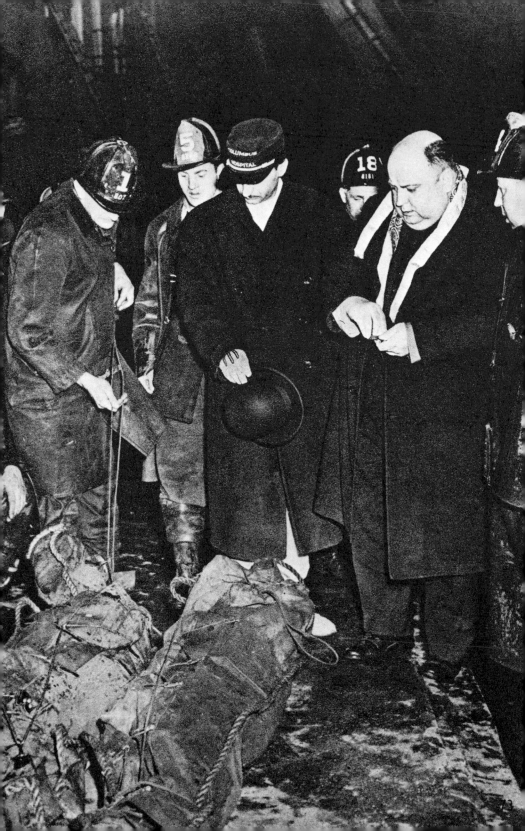

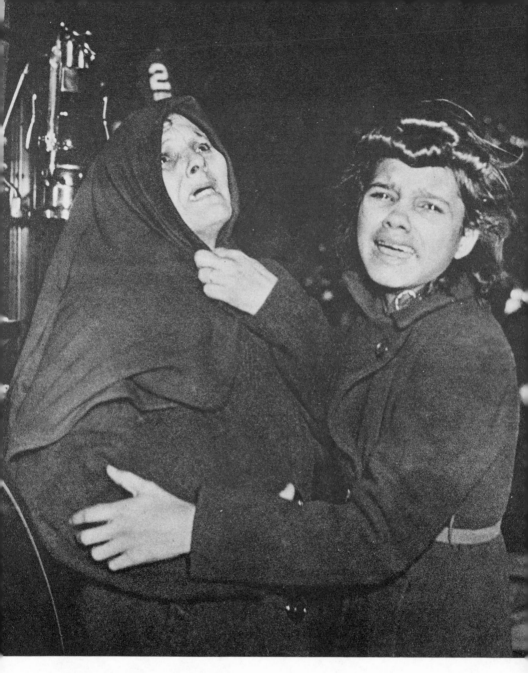

I Cried When I Took This Picture

Mother and daughter cry and look up hopelessly as another daughter and her young baby are burning to death in the top floor of the tenement . . . firemen couldn't reach them in time . . . on account of the stairway collapsing.

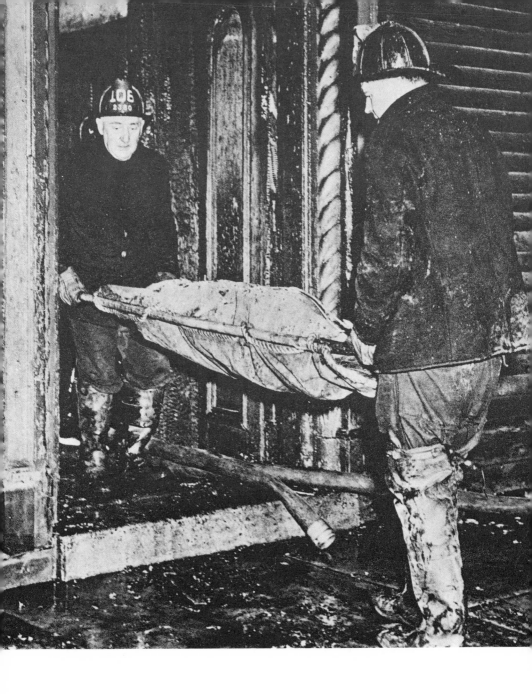

TRAGEDY

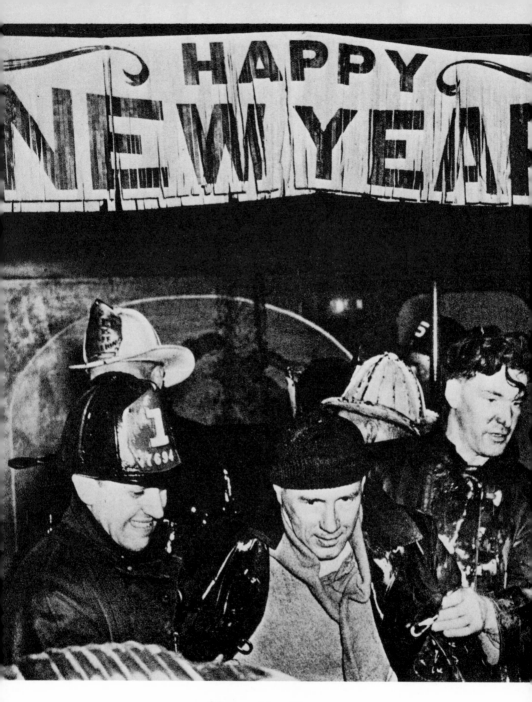

Happy New Year

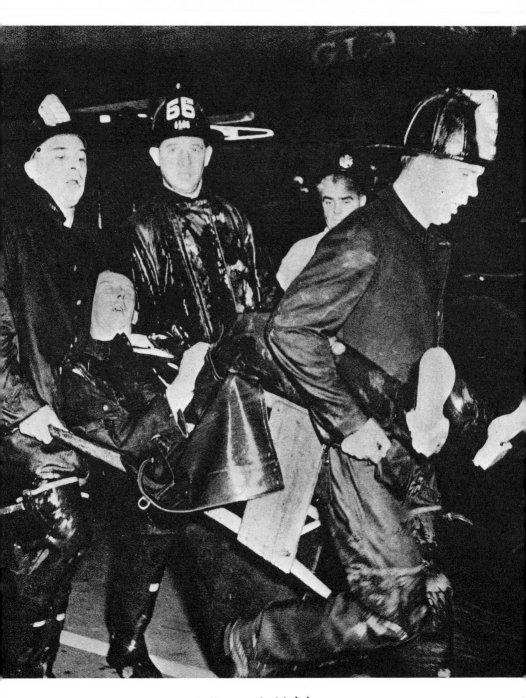

A Fireman's Holiday

EXPLANATION	DATE	AMOUNT	DISCOUNT	TOTAL
TWO MURDERS		35.00		35.0

4 MURDERS . . .

People get bumped off . . . on the sidewalks of New York. The
only thing unusual about these killings is that they are never
solved. The guys are always neatly dressed . . . fall face up . . .
with their pearl gray hats alongside of them. Some day I'll
follow one of these guys with a "pearl gray hat," have my
camera all set and get the actual killing . . . could be . . . I
got the above statement with check from Life magazine.
Twenty-five dollars was for the murder picture on the right . . .
the other picture they bought was only a cheap murder, with
not many bullets . . . so they only paid ten dollars for that.

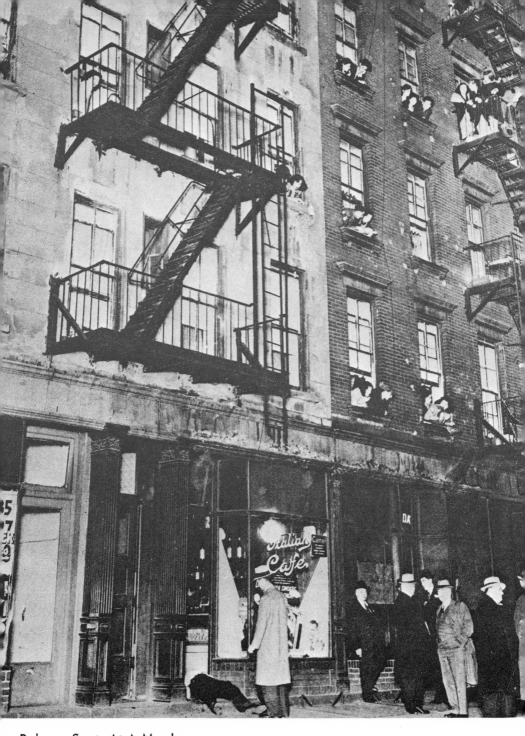

Balcony Seats At A Murder

This happened in Little Italy. Detectives tried to question the people in the neighborhood . . . but they were all deaf . . . dumb . . . and blind . . . not having seen or heard anything.

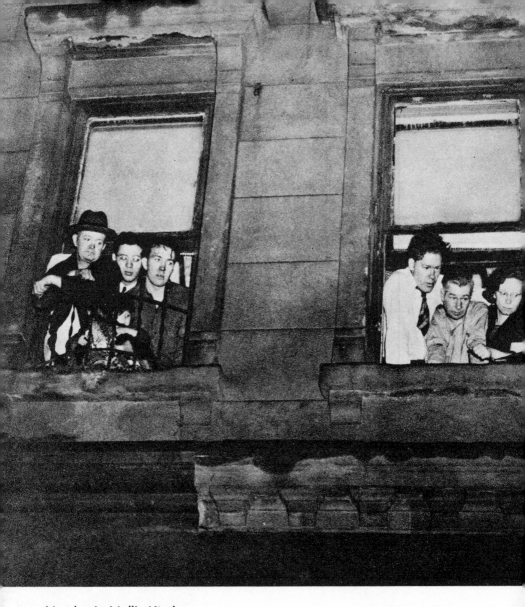

Murder In Hell's Kitchen

One looks out of the windows . . . talks about the weather with a neighbor . . . or looks at a murder.

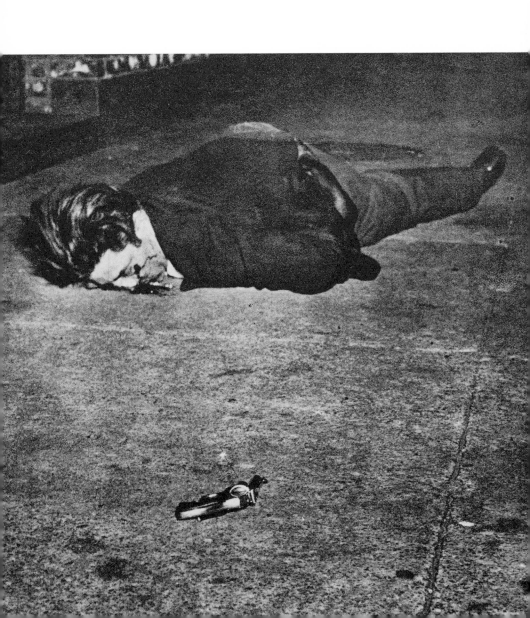

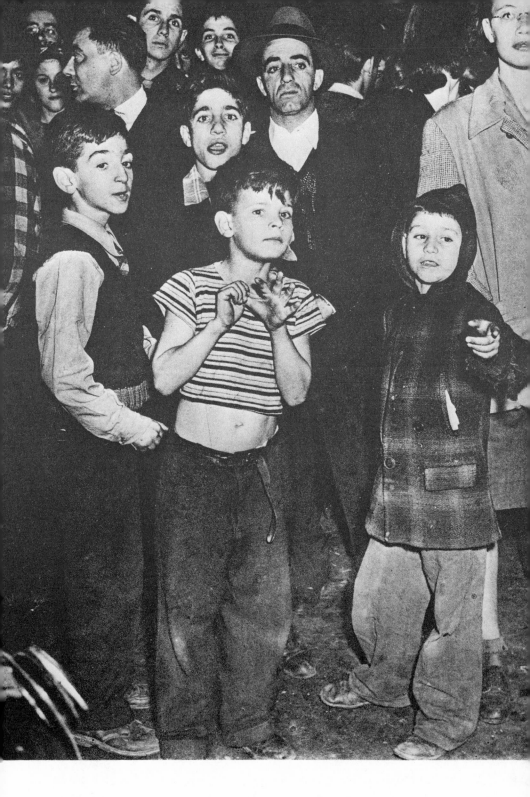

Geel

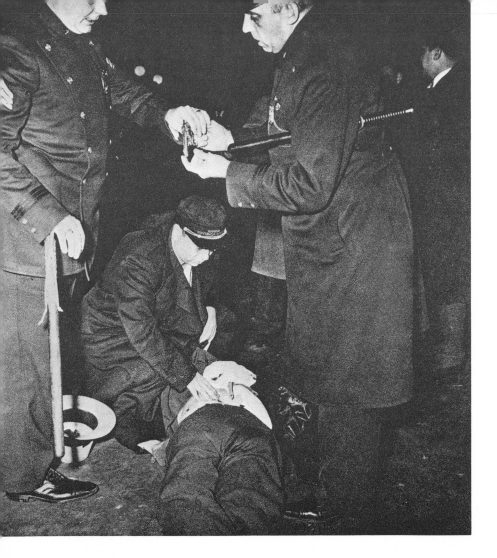

Crime and Punishment

This happened at eight o'clock on a Sunday night. . . . People were rushing to the movies . . . there was a good double feature at Loew's Delancey Street . . . one being a gangster picture . . . a few blocks away . . . in the Essex Diner . . . a bus boy was pasting a sign in the window, "Chef's Special." A man walked in . . . he wasn't looking for any specials, he had a gun. And this was a stickup. He grabbed the money from the cash register and ran out. A cop saw him and gave chase. The holdup man hid behind a parked car and started firing at the cop. The policeman fired back and killed the bandit. Here's the cop just after the shooting . . . very nervous, for he might have hit some innocent passers by, giving the gun to the sergeant. The cop got a medal . . . the gunman got the bullets.

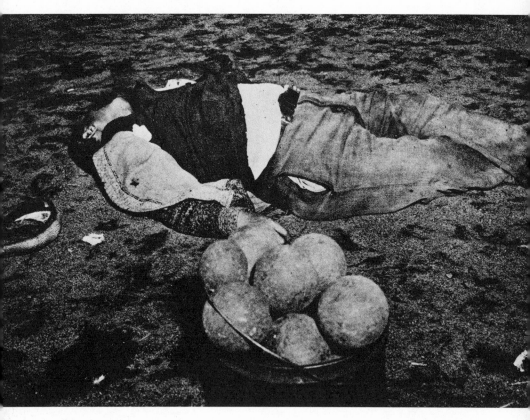

This was a friendly game of Bocci, an Italian game very popular on the East Side and played on empty lots. An argument started and one of the players was shot and killed.

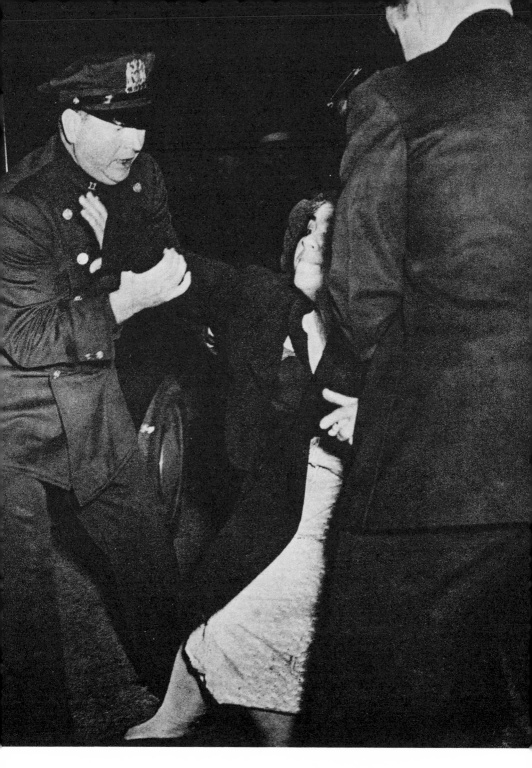

The dead man's wife arrived . . . and then she collapsed.

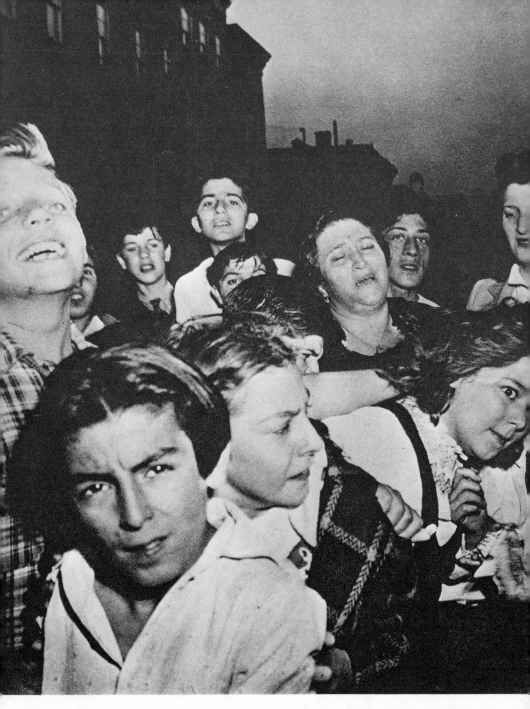

A woman relative cried . . . but neighborhood dead-end kids enjoyed the show when a small-time racketeer was shot and killed . . .

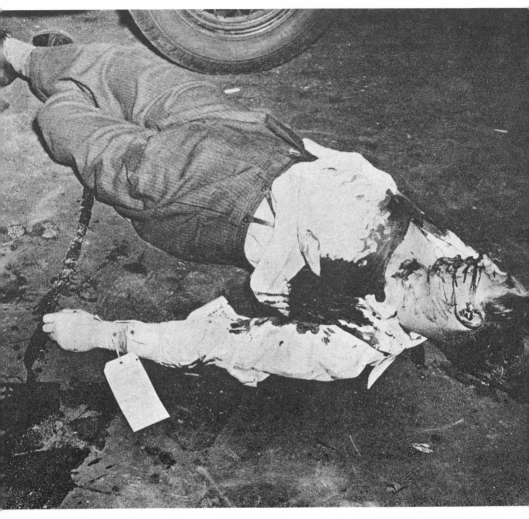

Here he is . . . as he was left in the gutter. He's got a D.O.A. tied to his arm . . . that means Dead On Arrival.

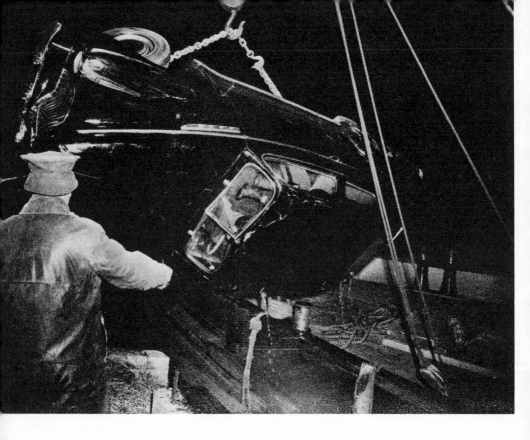

5 SUDDEN DEATH

It's a lovely evening . . . the full moon is out. A car somehow or other drives off the pier into the river. The couples in the parked cars in "Lovers' Lane," as the pier is called, run out of the cars dressed in pajamas. Police boats arrive with powerful searchlights which illuminate the waters as other cops try to get a "bite" on the car. It is a long, trying job to locate the car in the river.

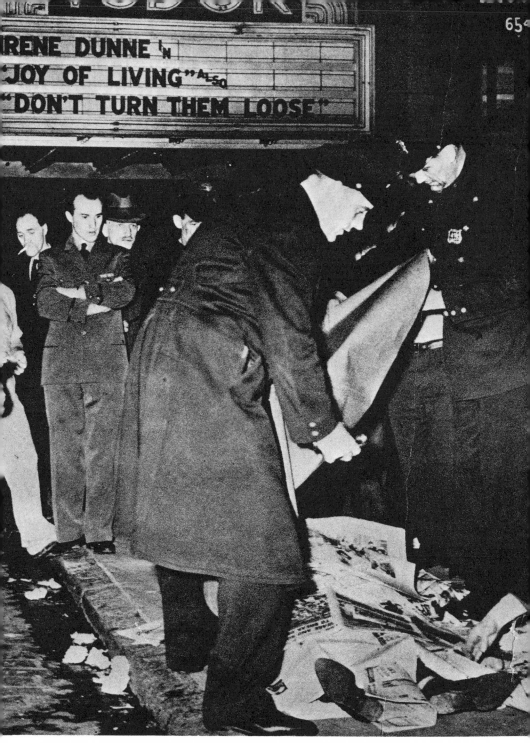

This man covered up with newspapers was killed in an auto accident. The driver of the car was arrested, but he put up such a terrific battle . . . cops had to put handcuffs on him.

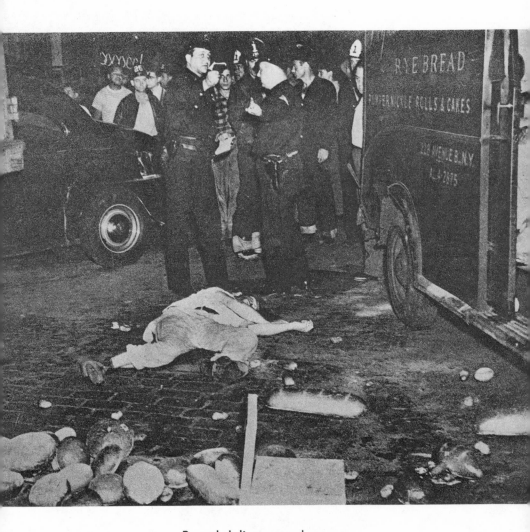

Bread delivery truck

. . . in collision with woman driver.

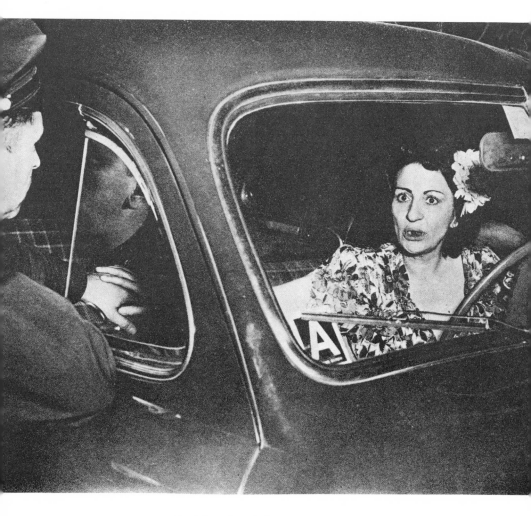

Sudden death for one

. . . sudden shock for the other.

6 THE BEST PEOPLE GO TO HEAVEN

This was a fashionable society funeral. The obituary had received almost a whole column in the *New York Times*. It was just like opening night at the opera. The cute Rolls Royces arrived with their invited guests. A mob of spectators stood on the sidewalk, watching and listening to the beautiful organ music coming from the church.

The uniformed chauffeurs and the professional pallbearers were grouped in a huddle on the steps of the church . . . they were bored and kept asking what time it was . . . hoping that they would get it over with, as they had some bets to place on the day's races with their bookies. The talk drifted on which tipster was best to follow in the papers. One of the pallbearers started cursing the *New York Daily Mirror* and their tipsters Joe and Asbestos, who daily give out tips in their comic strip, saying he was out over sixty dollars by following them, and that they were nothing but a couple of bastards who must be working for the bookies instead of the players.

Across the street from the church, delivery men were bringing in baskets of chopped meat to the Hamburger Heaven for the dinner rush; the group on the steps broke up with the pallbearers and the chauffeurs hiding their racing forms and scratch sheets inside their coats. Then the casket came down the steps and was placed hurriedly inside the hearse. An auto driving by stopped to watch . . . "Oh, what a beautiful morning" was coming out of the radio, sung by a tenor with a pansy voice. Somehow the car got sandwiched in with the funeral procession and they all made a turn up Fifth Avenue.

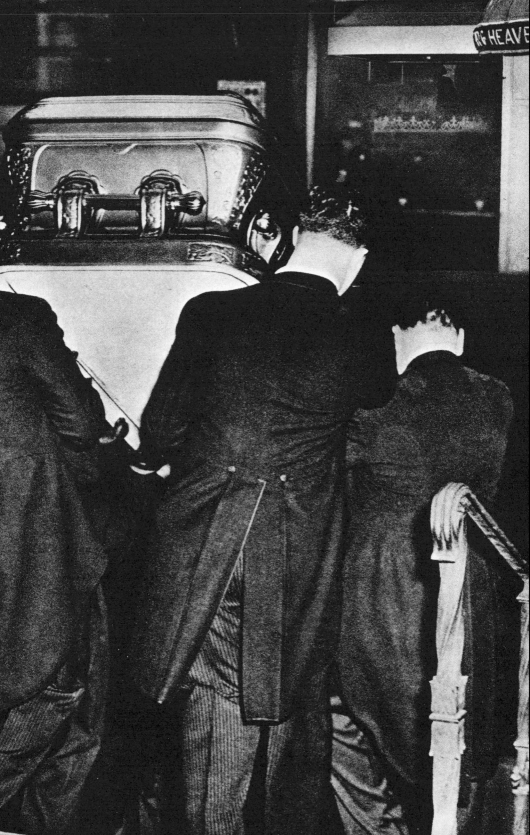

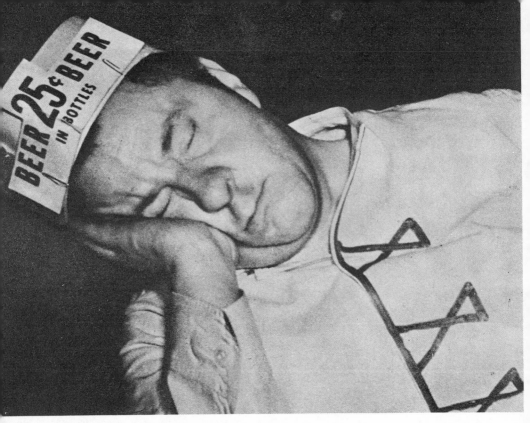

Tired business man at the circus . . .

7 THE ESCAPISTS . . .

Laugh—it's good for you . . . forget all about shoe coupons . . . red stamps . . . and gas rationing . . . and that lonely ache in your heart every night waiting for First Class Private G. I. Joe to come home safely. That's the kind of picture I like to take . . . it's funny, people will laugh and have a good time when they have money for a ticket. I even laughed myself . . . and forgot all about my inferiority complexes.

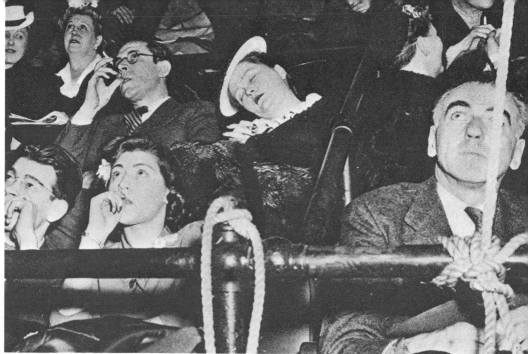

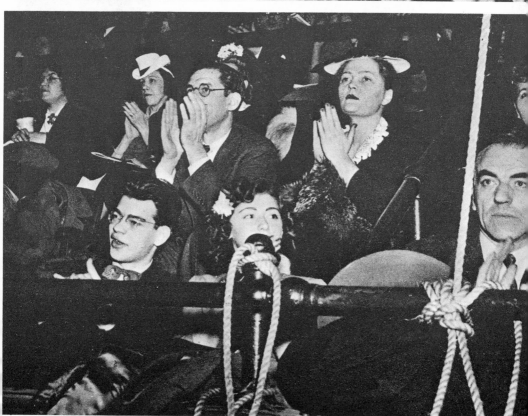

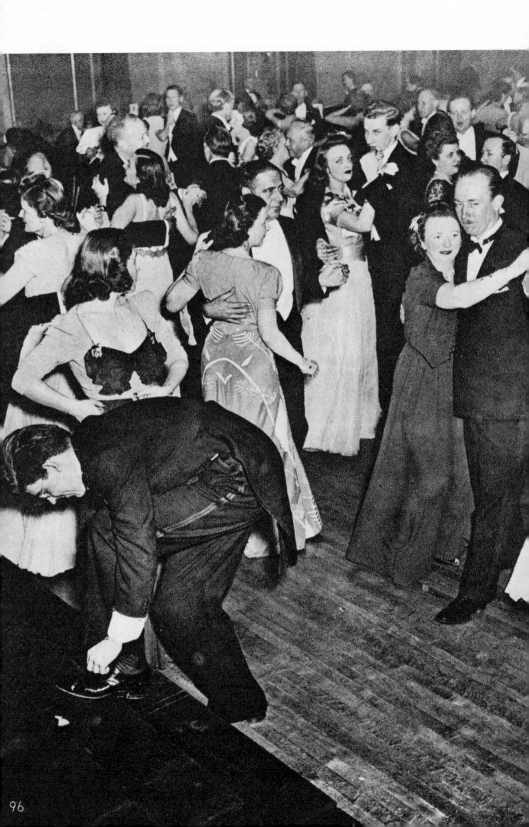

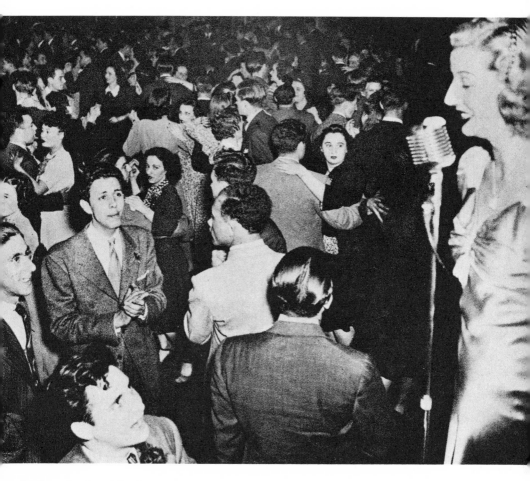

Ball at the Waldorf-Astoria

A gay time was had by all except for the guy whose shoelace became untied
. . . and at the United Mine Workers' Ball in the Hotel Diplomat on west
43rd street. The young miners . . . liked the Blues singer "Oh so much."

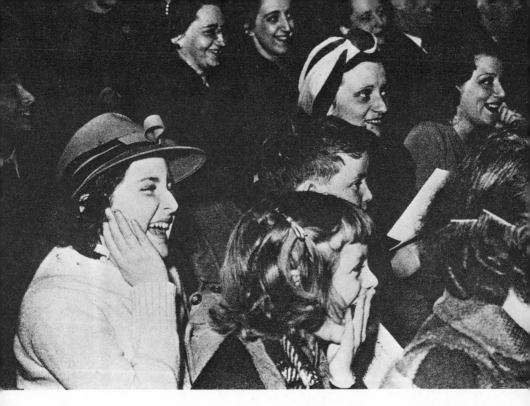

The neighborhood Air Raid Wardens put on a show at the Educational Alliance Hall. The skit had to do with an absent-minded air raid warden who, hearing the sirens in the middle of the night . . . grabs his wife's bloomers by mistake and runs out into the street. A good time was had by all.

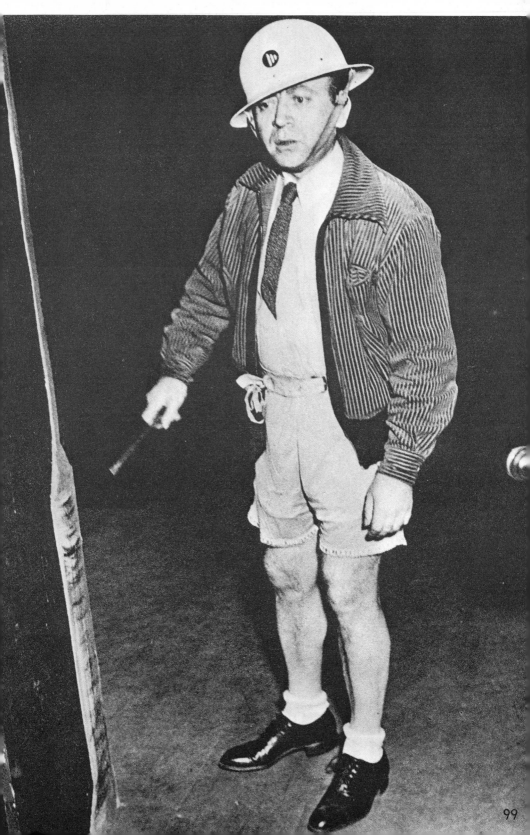

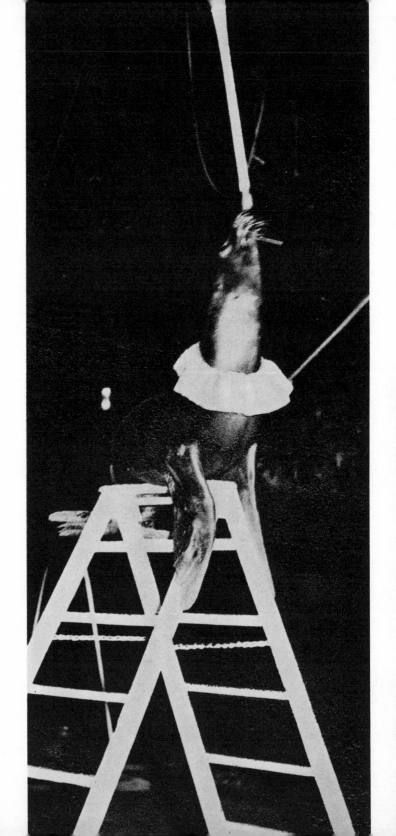

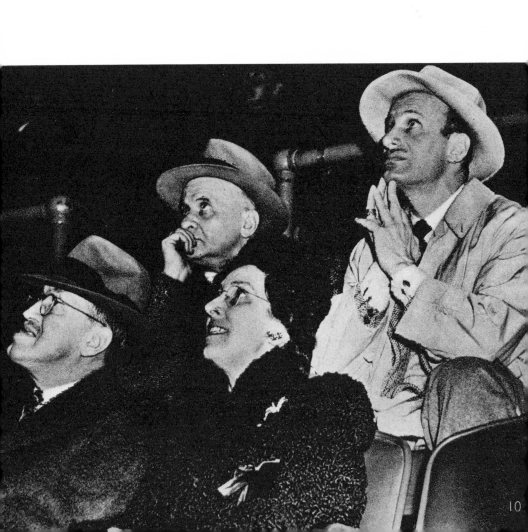

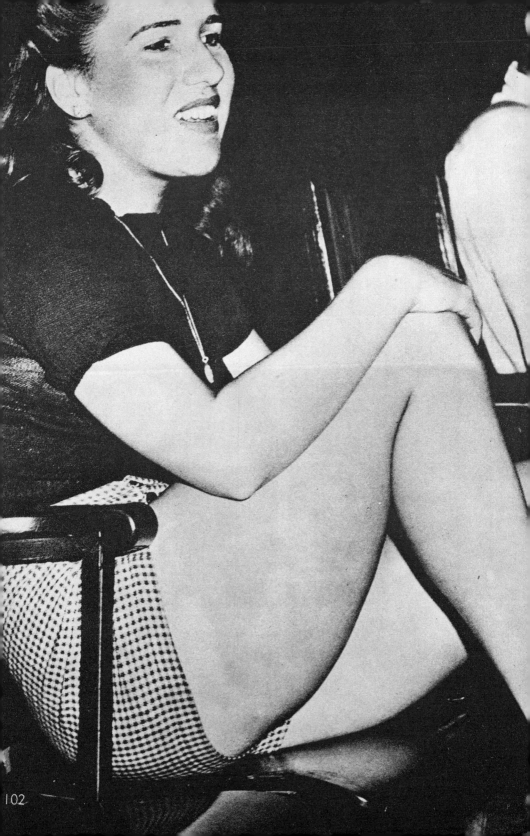

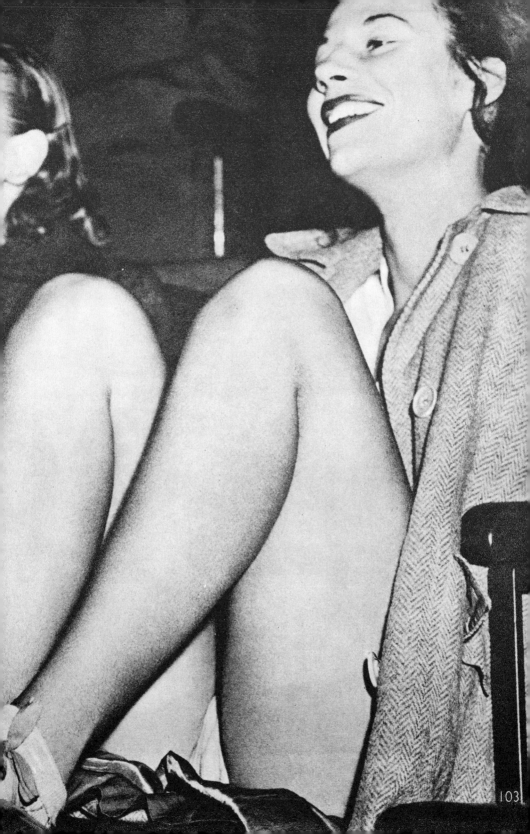

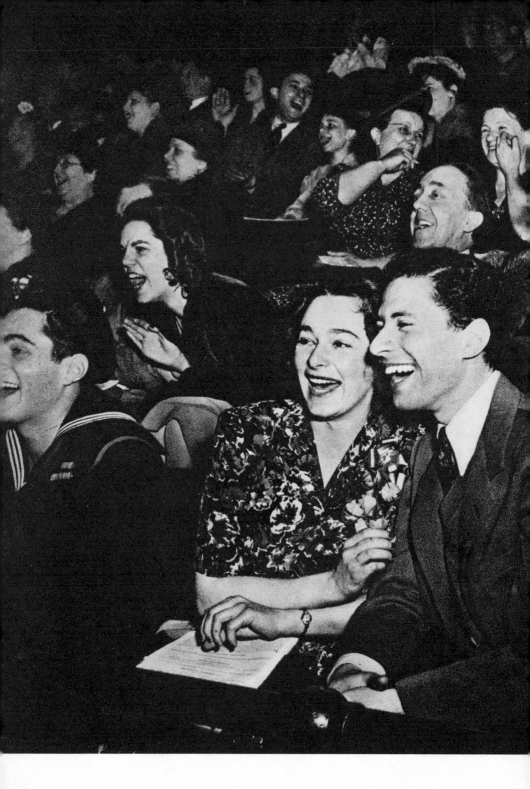

Go on and laugh too . . . don't be afraid . . . all men are born free and equal . . . and it's no crime to laugh . . . even if your skin is black.

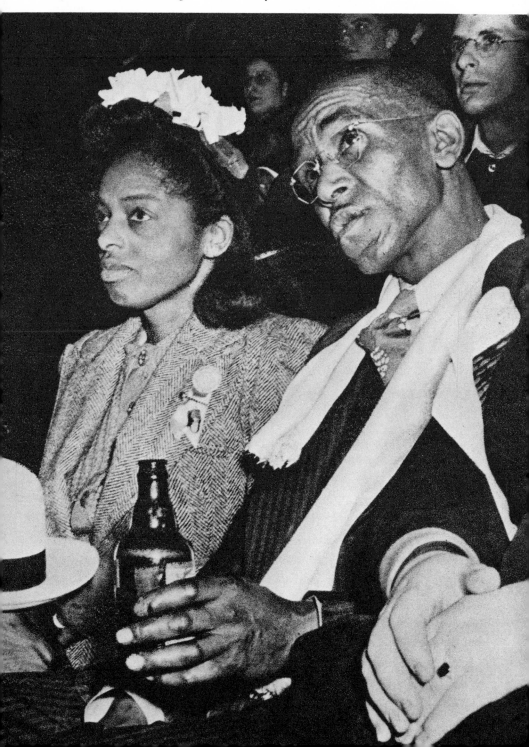

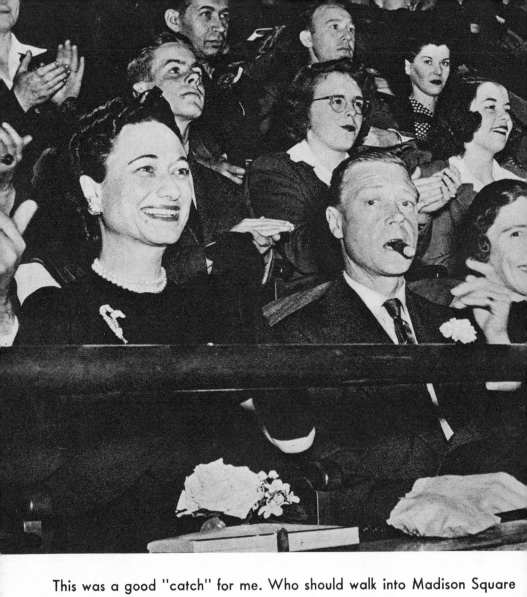

This was a good "catch" for me. Who should walk into Madison Square Garden one night while the circus was playing there but the former King of England with Wally Simpson . . . the woman he gave up his throne for, because he loved her. Always on the alert . . . I quickly snapped their picture. Do you want to know why? Well, the Cigar Institute of America wants photos of celebrities smoking cigars . . . and they offer prizes to the photographers who get some pictures published in newspapers. . . . (They do this to counteract the movies which show gangsters smoking cigars from the side of their mouths.) Oh well, this shot got published. I won first prize—fifty dollars—a medal . . . and a pocketful of good cigars. After I snapped their Highnesses' picture, I shook hands with them and wished them luck.

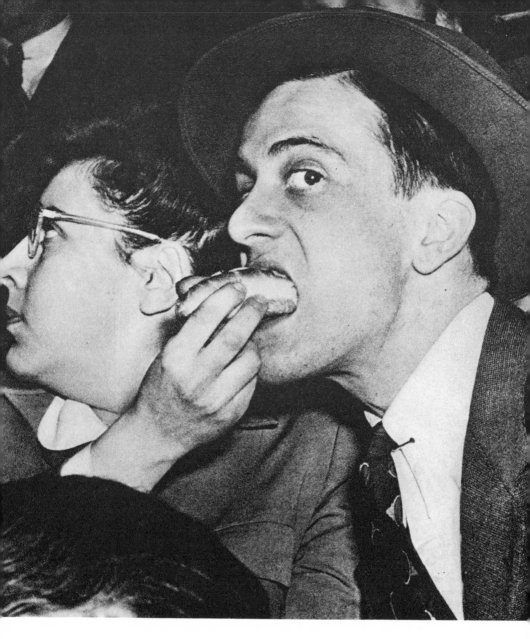

John Doe and his girl friend . . .

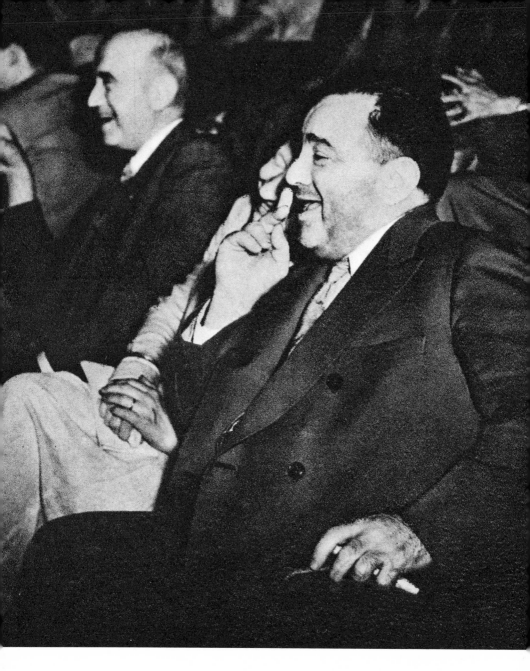

Guess who this is . . . it's the "Little Flower" or, to be more dignified, His Honor, Fiorello La Guardia, Mayor of New York City . . . I was afraid to disturb him with the bright glare of the flash bulb . . . so took his photo in the dark, using Invisible Light . . . I made "Butch" famous by always photographing him at fires.

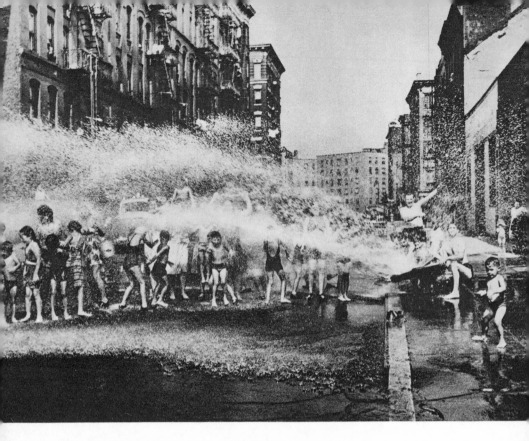

Escape from the heat ... these tenement people opened up the water hydrant ... placed a barrel over it ... and got cooled off.

But a cop came around and shut the hydrant off. . . . As soon as the cop leaves . . . the hydrant will be opened up again.

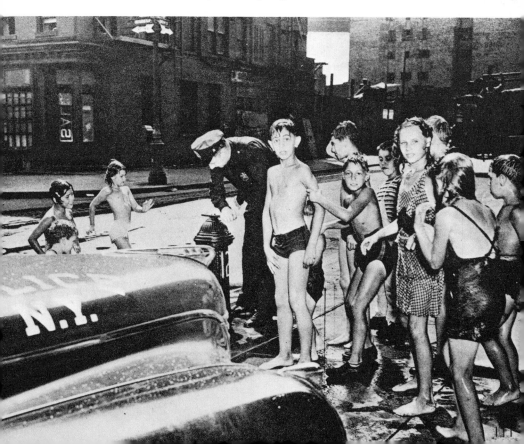

8 "FRANKIE"

Oh! Oh! Frankie. . . .

The line in front of the Paramount Theatre on Broadway starts forming at midnight. By four in the morning there are over five hundred girls . . . they wear bobby sox (of course), bow ties (the same as Frankie wears) and photos of Sinatra pinned to their dresses. . . . They bring their lunches . . . sandwiches wrapped in paper bags . . . and thermos bottles full of hot coffee . . . with paper cups. . . . By seven in the morning when daylight breaks, some of the girls read movie fan magazines, others play cards, a favorite game being "Old Maid." While still others proudly show their scrap books of Sinatra photos clipped from newspapers and magazines to the others in line. . . .

By eight in the morning there are over ten thousand trying to get in line . . . that's the time the box office opens up. . . . The opening day there was a riot. The next day the cops were prepared. There were:

1 deputy police chief inspector

3 captains

4 sergeants

5 policewomen

5 cops with their horses

41 temporary cops in civilian clothes with P. D. arm bands

60 cops

200 detectives

 2 emergency trucks

 20 radio cars

and an unannounced number of truant officers

and also . . .

Reporters

Photographers

and curious bystanders, etc.

The line moves slowly towards the box office. . . . Police-women yank out of the line those that appear to be under sixteen years . . . some of the girls cry, offer to show their Social Security cards as proof of age, and plead to be allowed to go inside the theatre as they had come all the way from Brooklyn and Long Island. . . . Meanwhile big trucks loaded with rolls of newsprint arrive at the Times Building which adjoins the theatre, unable to back up and unload, the Times guards clear the entrances and act as ushers, keeping the mob behind the ropes. (The next day an editorial appeared in the *New York Times* on the Sinatra menace.)

A big blow-up picture of Sinatra in front of the theatre is marked red with lipstick impressions of kisses, endearing messages of love, and even telephone numbers. The theatre is soon filled. The show starts with the feature (*Our Hearts Were Young and Gay*). This is the most heckled movie of all times . . . not that its a bad movie . . . just the opposite . . . but the girls simply didn't come to see that . . . as far as they

are concerned they could be showing lantern slides on the screen.

Then the great moment arrives. Sinatra appears on the stage . . . hysterical shouts of Frankie . . . Frankie . . . you've heard the squeals on the radio when he sings . . . multiply that by about a thousand times and you get an idea of the deafening noise . . . as there is no radio control man to keep the noise within ear level. Sinatra does a few numbers and leaves the stage hurriedly. Now the whole theatre is a bedlam of noises with the audience refusing to quiet down. Shouts of Frankie! . . . Frankie! . . . don't leave us . . . but the orchestra starts playing *The Star Spangled Banner* . . . they all get up . . . the noises cease . . . and then slump into their seats. . . .

Inside the lobby a big crowd is waiting patiently for seats . . . with the management wondering where to put them . . . as those inside are going to remain all day and night in the theatre for the full five shows . . . and that goes for Frankie too . . . a big mob is waiting at the stage door entrance . . . he dares not leave . . . so he's marooned inside the theatre . . . with a steady stream of messengers bringing him his lunch . . . laundry . . . and even a barber arriving in a taxi. . . .

At two in the morning the theatre closes up . . . the porters come in to clean up . . . some of the girls having been in all day and night and having seen all the five shows refuse to leave . . . and try to hide in the ladies room . . . but the matrons chase them out . . . so those having had some sleep during the picture, go outside and wait in line again . . . others take the subway home . . . will they get Hell when they get home!

They are a clannish bunch, the Bobby Soxers . . . and they talk among themselves that Frankie should be in the White House as President. One of the girls remarks sadly that that couldn't be . . . because Frankie is too skinny.

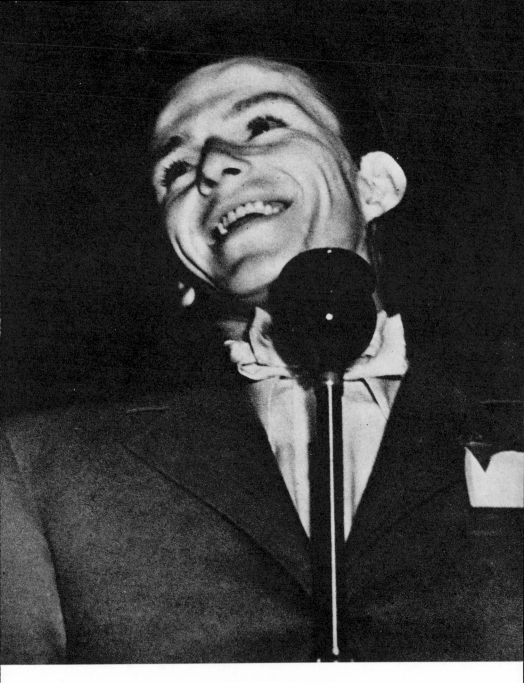

Sinatra appears smiling

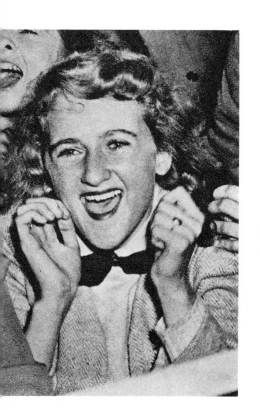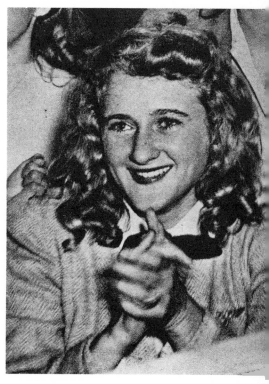

And a girl smiles too ...

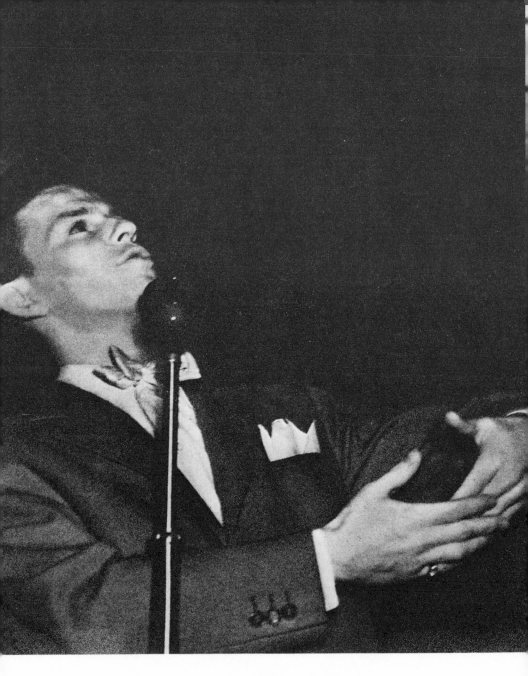

"Come To Me My Melancholy Baby."

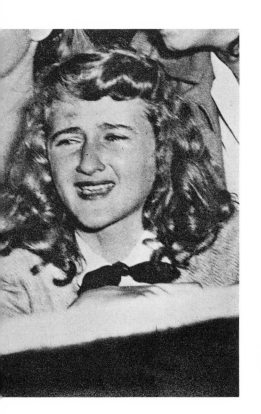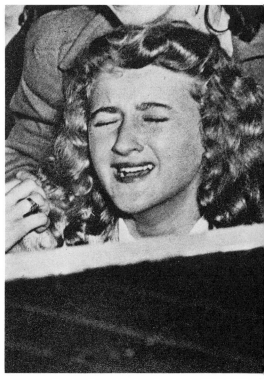

Then she cries.

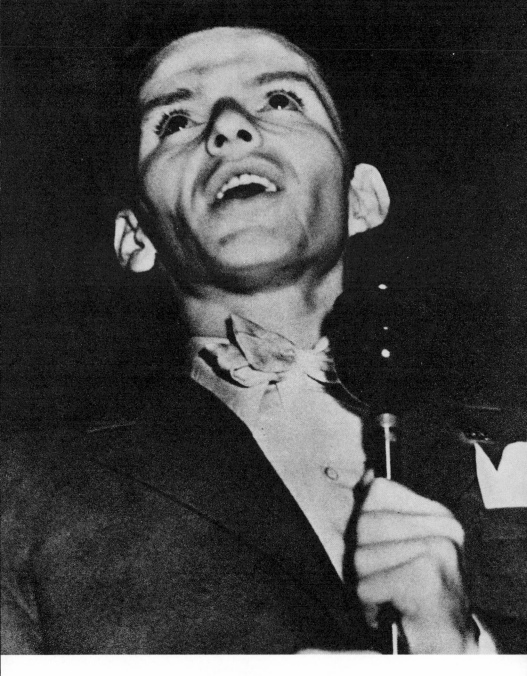

"Let Me Take You In My Arms."

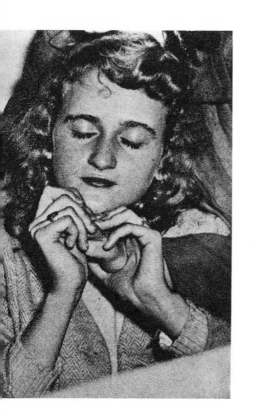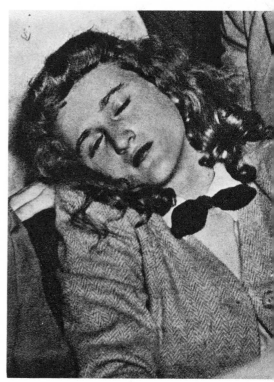

The Swoon

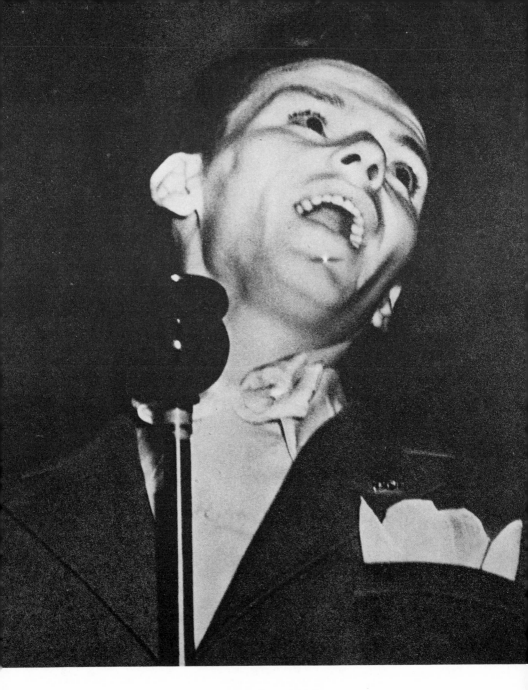

"I Dream of You."

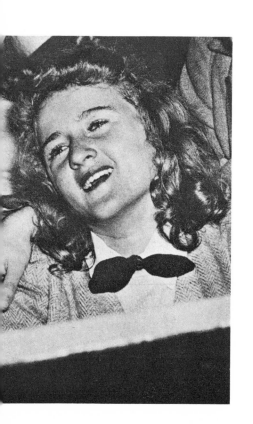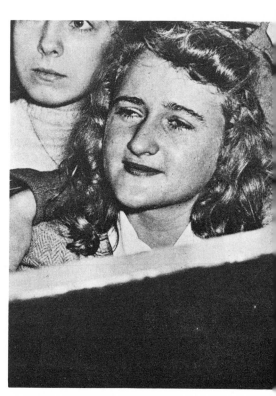

Ecstasy and exhaustion. . . .

9 THE OPERA

The crime teletype machine was quiet at police headquarters
. . . so I decided to sneak away and go to the opening of the
opera. I watched the last minute rehearsal. I had no invitation
but my press card was enough. War or no war, the Rolls
Royces, big and shiny, kept arriving. Some had two chauf-
feurs with the usual gas ration sticker in the windshield. I
guess if they ran out of gas one would steer while the other
one would push.

I took stock of the situation. It was a cold night. Inside the
warm lobby about two dozen photographers were lined up
Wolf Gang Fashion. If one flashed a bulb all the others did
too. It was like a game of "follow the leader." This is a big
night for the cameramen, with the papers and syndicates
sending only high class photographers who know society to
cover because before a paper will publish a photo of the
opening night the subject's name must be listed in the Social
Register.

I like to get different shots and don't like to make the same
shots the other dopes do . . . so I went outside into the street.
I started talking to a cop. On stories I always make friends
with cops . . . gangsters . . . prostitutes, etc. A nice Rolls Royce
pulled up . . . I waited 'till the occupants got out and snapped
the picture. I couldn't see what I was snapping but could
almost smell the smugness. I followed the women into the

lobby, where the other photographers then snapped their picture too. I knew then that I had photographed real society so I asked the two women their names and made them spell them out too. Reporters gathered around them and asked them, if, in these critical times, it was appropriate to wear so much jewelry. The older woman first apologized for wearing last year's jewels and added the reason she did it was to help morale. . . .

P. S. N. W. Ayer & Son, the big advertising agency who has the account of De Beers Consolidated Mines Ltd., that's the diamond trust, bought this picture for their files. They examined the photograph with a magnifying glass and said the diamonds were real. . . .

The theatre was jammed so I went into the grand tier where the board of directors of the Metropolitan Opera House have their private boxes and picked myself a nice private box. There was another occupant, a director who kept his high silk hat on. I gave him a couple of dirty looks but he paid no attention to me or to the usher, who was evidently afraid to go near him.

During the intermission I went into the packed salon to watch what was going on. Cameramen were shooting fast and furious. Press agents, seeing my camera, pointed out notables to me but I refused to waste film or bulbs as I don't photograph society unless they have a fight and get arrested or they stand on their heads.

One woman dressed in ermine was pleading with her escort for a ham sandwich. Another couple was saying it was "well done." I don't know whether they were talking about their Thanksgiving turkey or the opera.

125

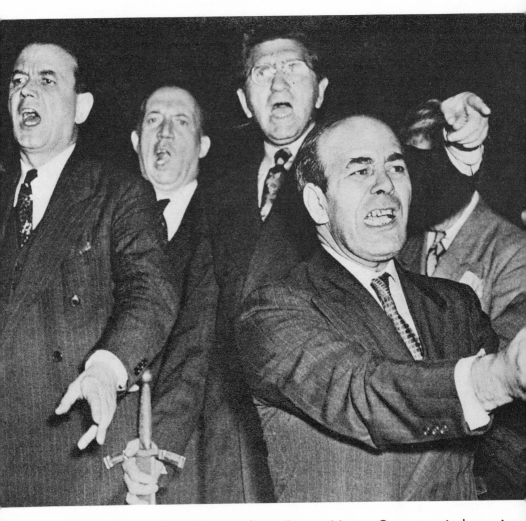

Male singers of the Metropolitan Opera House Company in last minute rehearsal for opening night. . . .

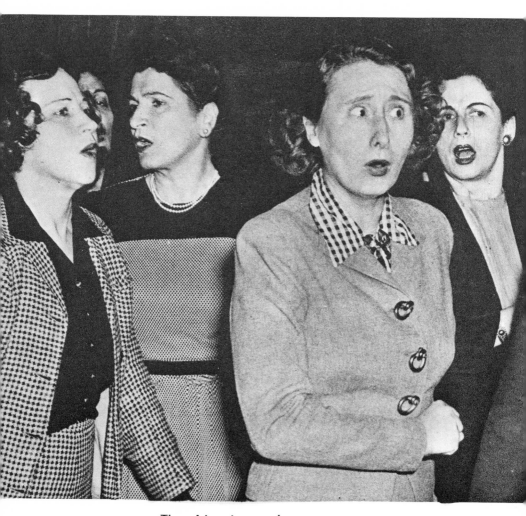

The girls rehearsed too. . . .

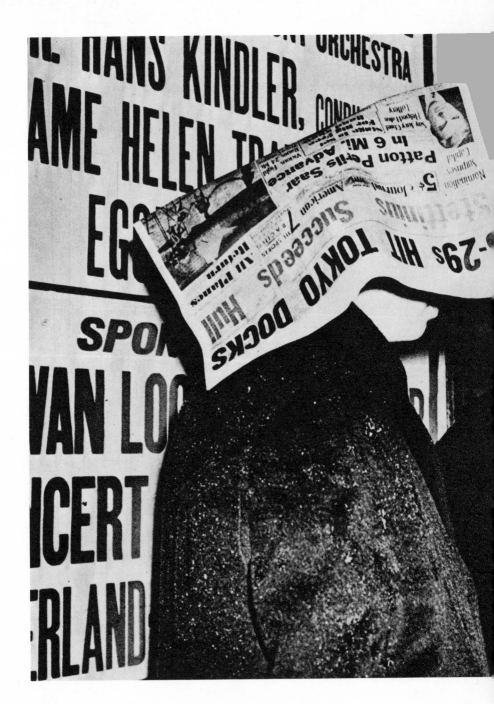

The common people waited in the street in the rain . . . for standing room . . .
while Society arrived wearing galoshes and pearls. . . .

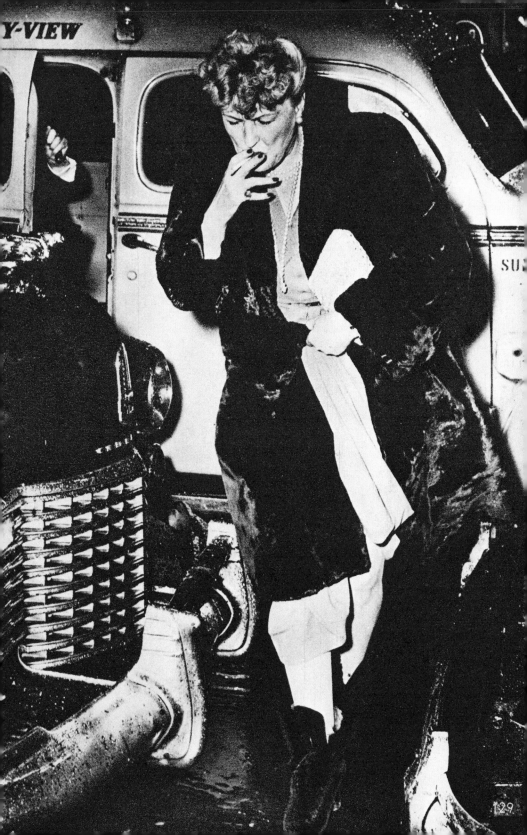

129

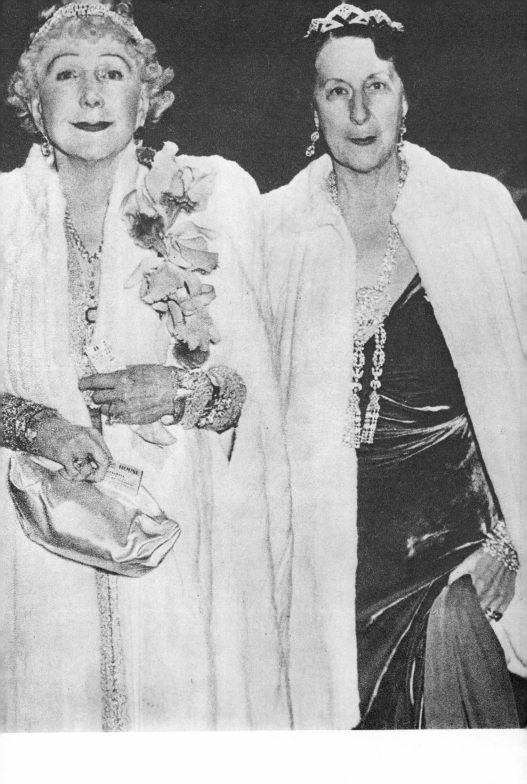

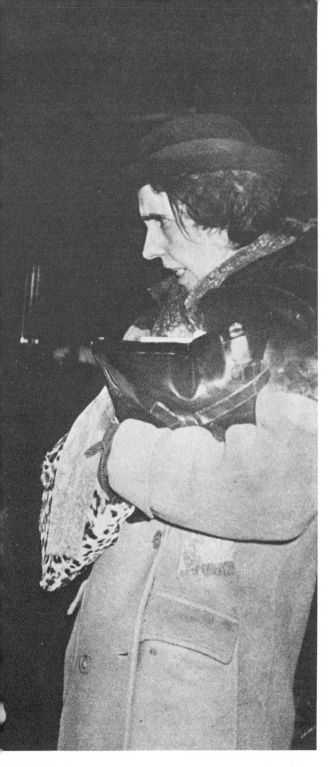

The Critic

Music
"Lovers"

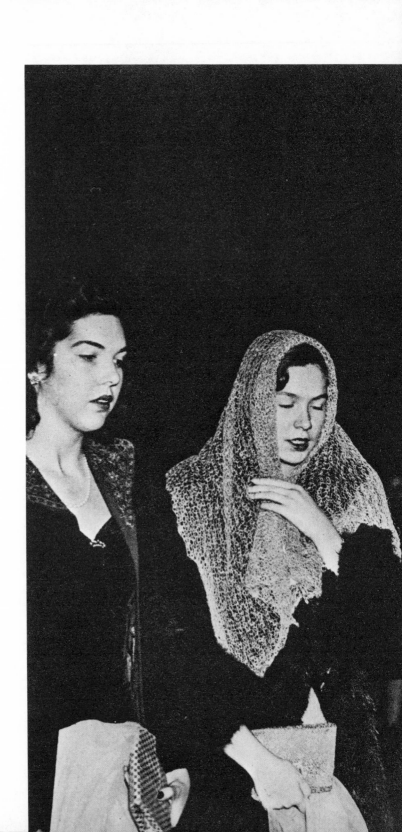

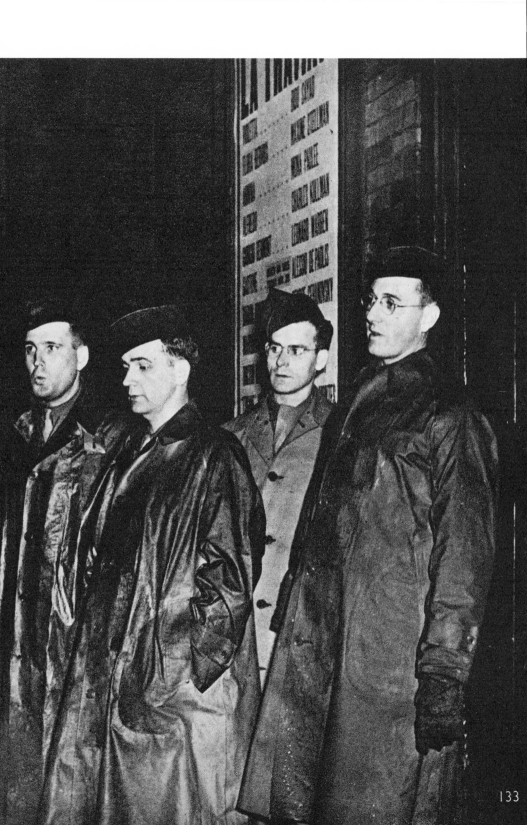

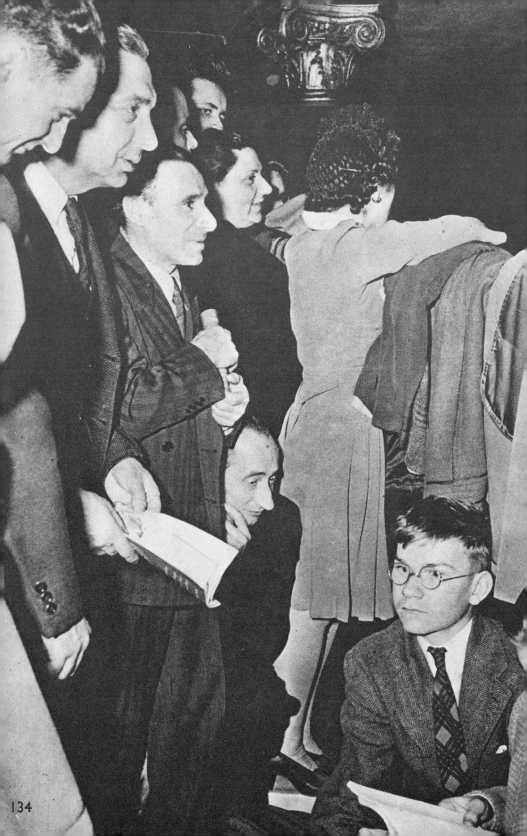

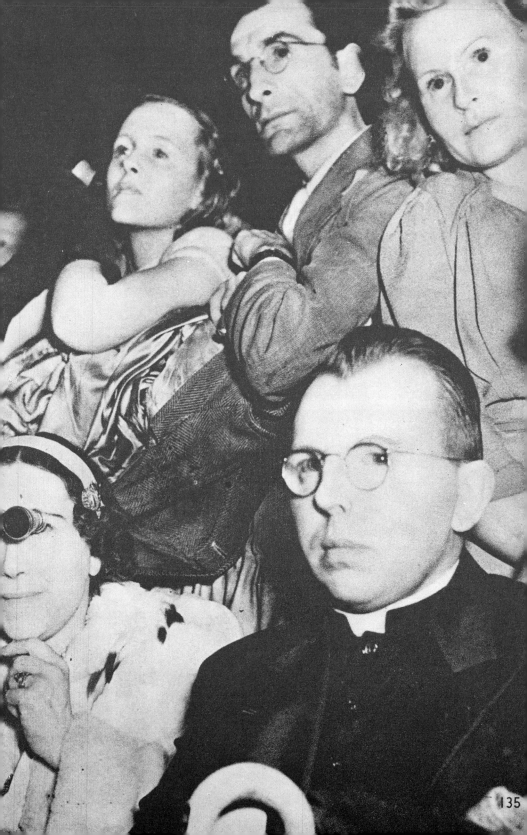

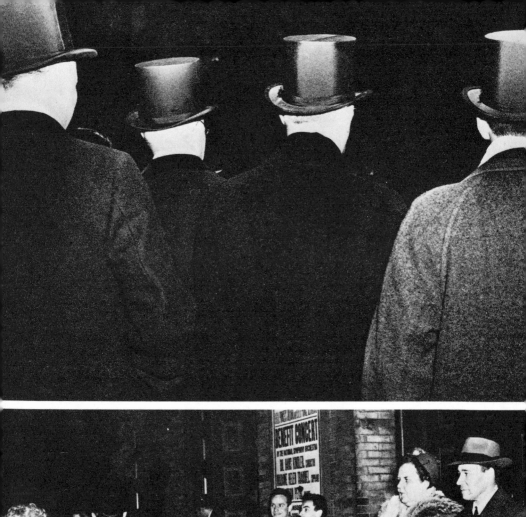

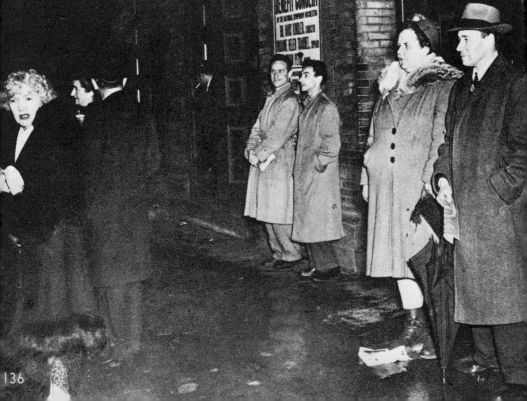

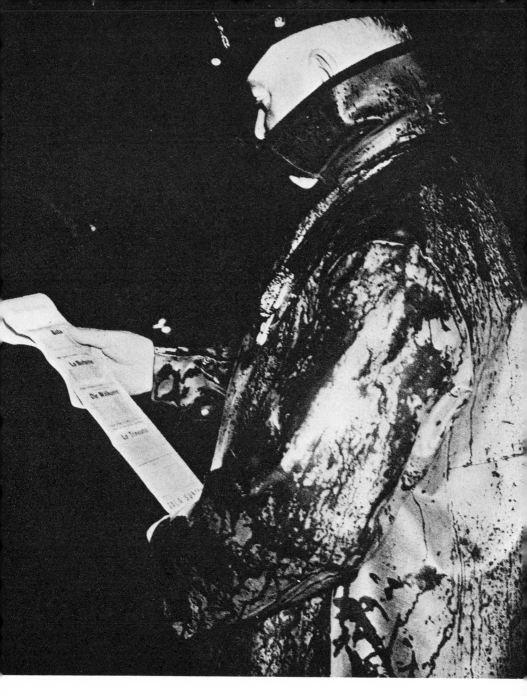

The four High Hats are waiting for James and the limousine . . . when the others had gone this dowager was still waiting under the marquee wondering what had become of her chauffeur. A couple passing by picked up a program from the sidewalk. . . END OF FIRST NIGHT.

10 THE BOWERY

At No. 267 Bowery, sandwiched in between Missions and quarter-a-night flop houses, is "Sammy's," the poor man's Stork Club. There is no cover charge nor cigarette girl, and a vending machine dispenses cigarettes. Neither is there a hat check girl. Patrons prefer to dance with their hats and coats on. But there is a lively floor show . . . the only saloon on the Bowery with a cabaret license.

As the customers arrive from uptown in cabs, they are greeted by a bunch of panhandlers who don't ask for the usual "got a nickel for a cup of coffee mister," but instead for a dime for a glass of beer . . . and get it too. Inside, the place is jammed with the uptown crowd mingling with the Bowery crowd and enjoying it. But towards midnight some odd types drop in for a quick one. There is a woman called "Pruneface," a man called "Horseface" . . . "Ethel" the queen of the Bowery who generally sports a pair of black eyes that nature did not give her, a man with a long white beard, who old timers say is looking all over the Bowery for the man who forty years ago stole his wife . . . they wonder when the two meet whether the wife-stealer will get beat up or thanked.

While I was there absorbing the atmosphere and drinks, a midget walked in . . . he was about three and a half feet. I invited him for a drink. He told me that he had just arrived from Los Angeles, where he had been working for a Brown & Williams Tobacco Co., walking the streets dressed as a

penguin. The midget was flush and started buying me drinks. He proudly showed me his social security card, told me that he was thirty-seven years old, was single as the girls were only after money, that once in a while he got some affection, but had to pay for it. . . . After the seventh round he got boisterous and offered to fight any man his size in the house. Sammy grabbed the midget and threw him out through the doorway which has a red neon sign saying "Thank you, call again," hollering at him not to ever come back again. Sammy's has a blacklist just like Billingsley's Stork Club uptown.

Sammy greets all his patrons at the door. I noticed he frisked some of the Bowery ones. He told me that they were the "bottle" babies and he could spot them by the bulge in their hip pockets. They would try to smuggle in a bottle of "smoke" into Sammy's place to drink in the washroom because if they drank out in the street or hallways the cruising patrol wagons would pick them up. Sammy is wise to all the tricks of the Bowery chiselers. but he is also a friend and always ready to lend a helping hand . . . lending money so a man can get cleaned up, food and a room while he is getting over a hangover. I know Sammy gave $100 without being asked for it for a woman in the neighborhood who died and there was no money for the funeral. He also takes care of his customers' valuables. I saw one woman at the bar give Sammy her wrist watch and thirty dollars to save for her till the following day, and I also saw him turn men away from his bar, telling them not to drink till their day off.

Sammy is known as the "Mayor of the Bowery" and his ambition is to become Mayor of New York City. And when that happy day arrives Sammy promises free drinks in every gin mill in town.

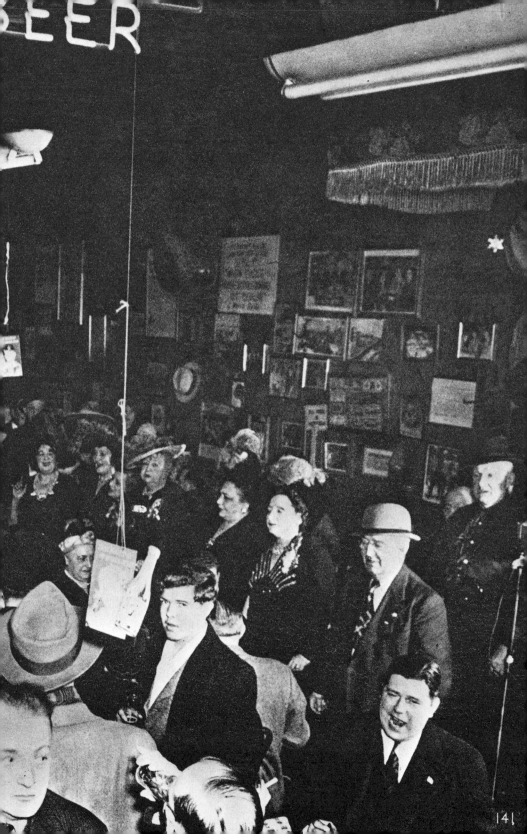

141

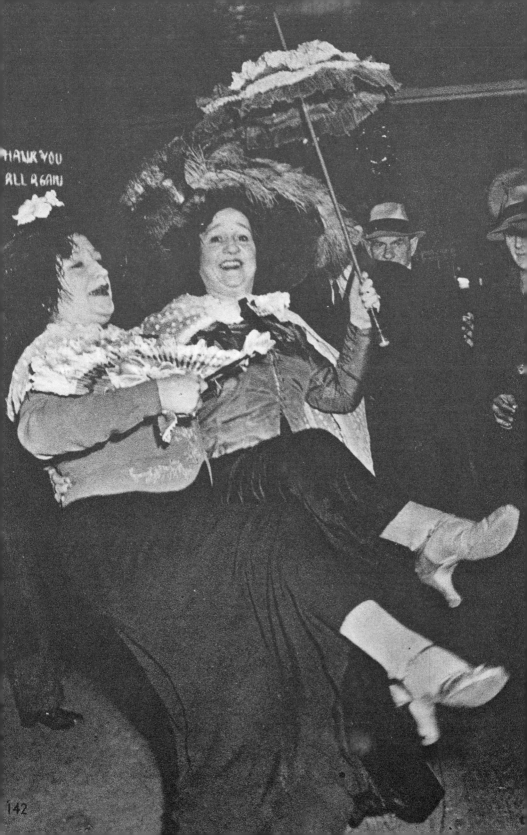

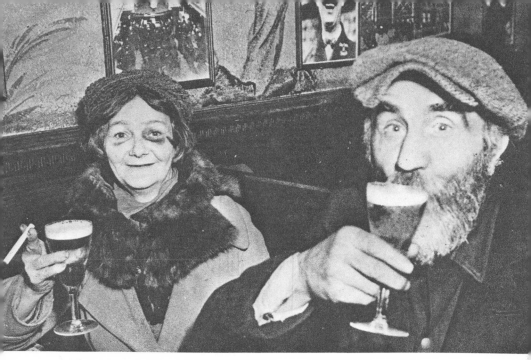

That's Ethel Queen of the Bowery ... with her boy friend.

Sherman Billingsley of *the* Stork Club ... dropped into "Sammy's, the poor man's Stork Club," on the Bowery ... to give a look.

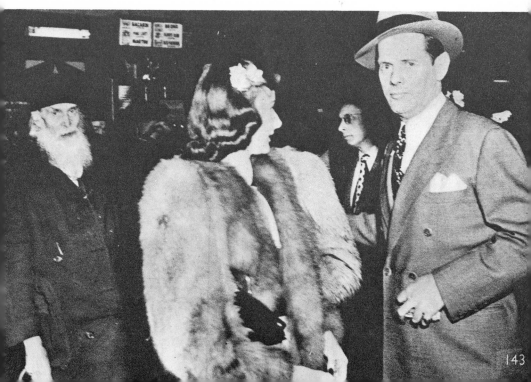

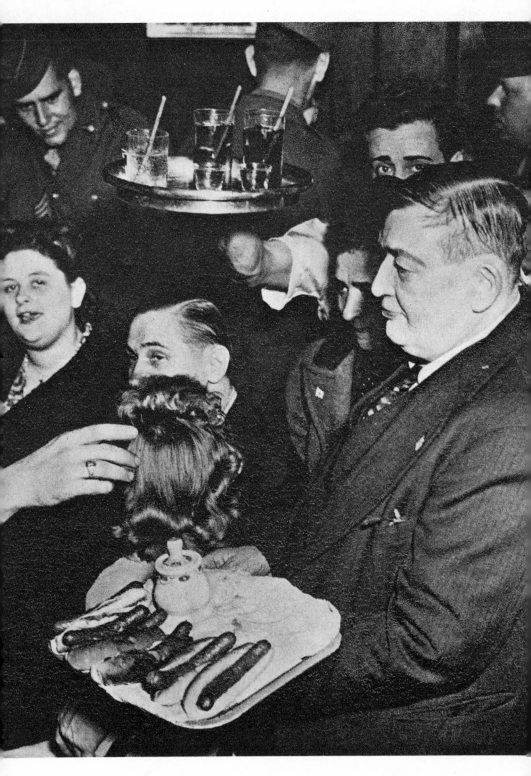

Peddlers drop in selling hot dogs . . .

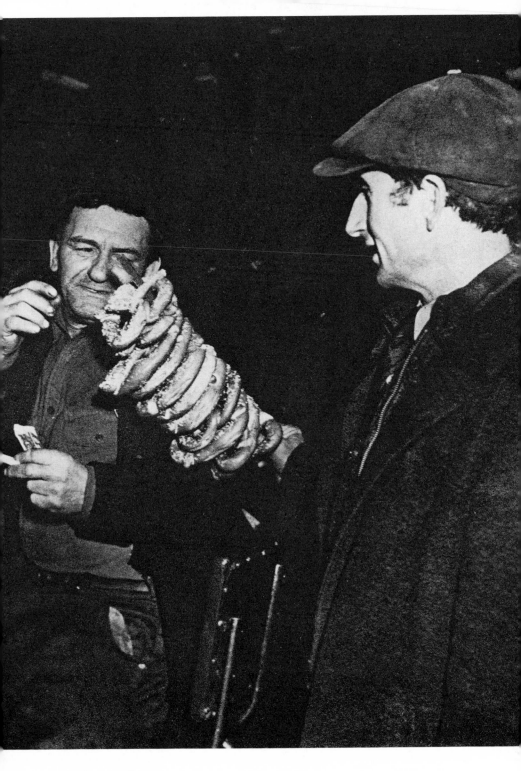

. . . and pretzels too. . .

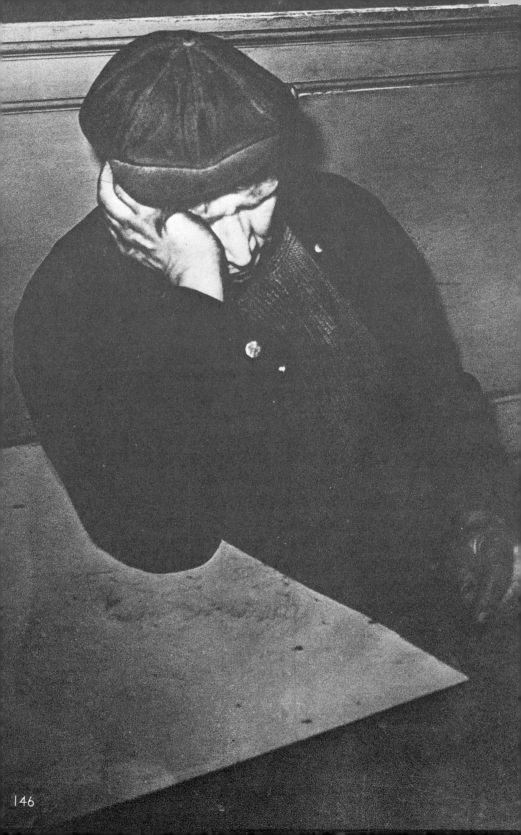

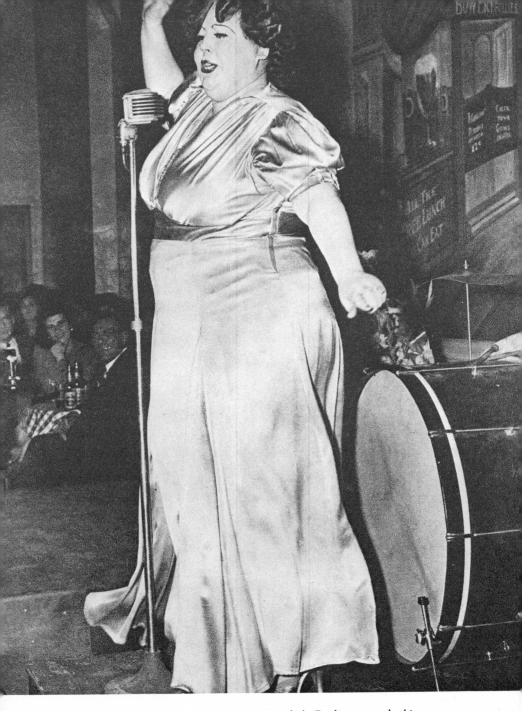

Introducing Norma, the star of Sammy's Foolish Frolics . . . shaking every-
thing that nature gave her . . . and not getting much response from the
Bowery playboy, on left . . . Norma's ambition is to understudy Mae West
. . . but that will be a sorry day on the Bowery . . . because who will under-
study Norma?

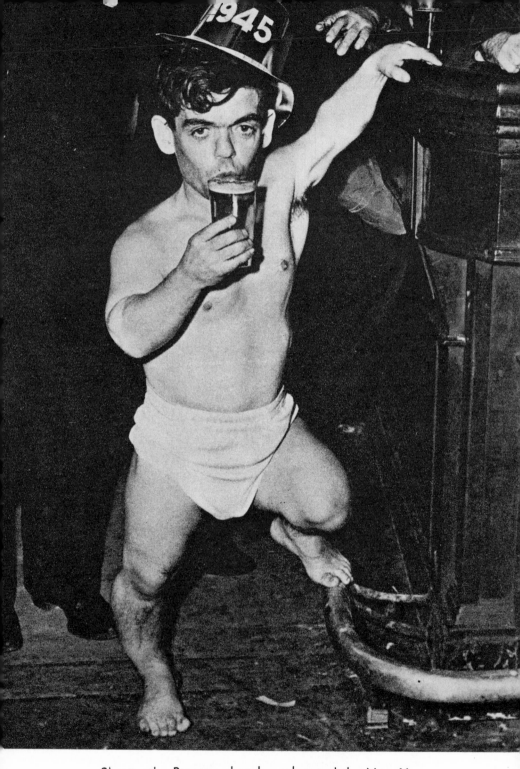

Shorty, the Bowery cherub, welcomed the New Year. . . .

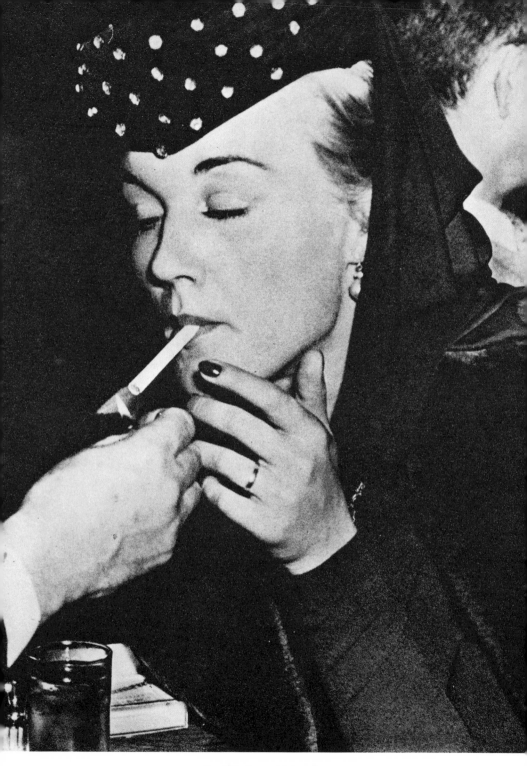

Sophisticated Lady

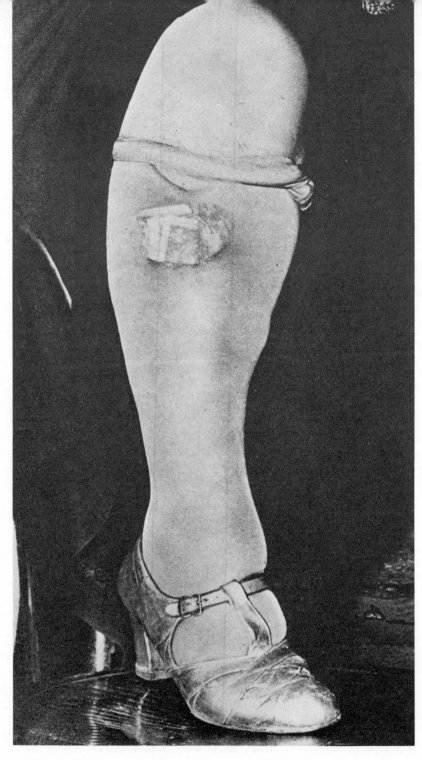

Ladies keep their money in their stockings . . .

And gents dance with their caps on. . . .

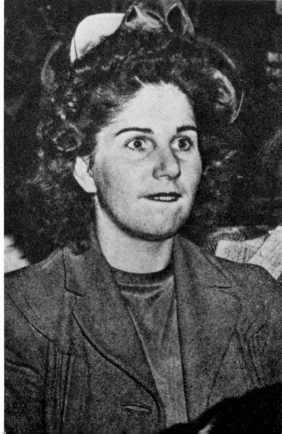
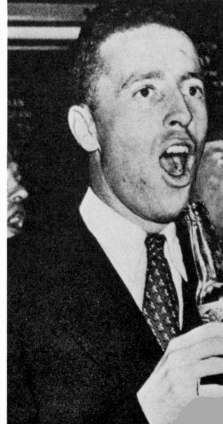

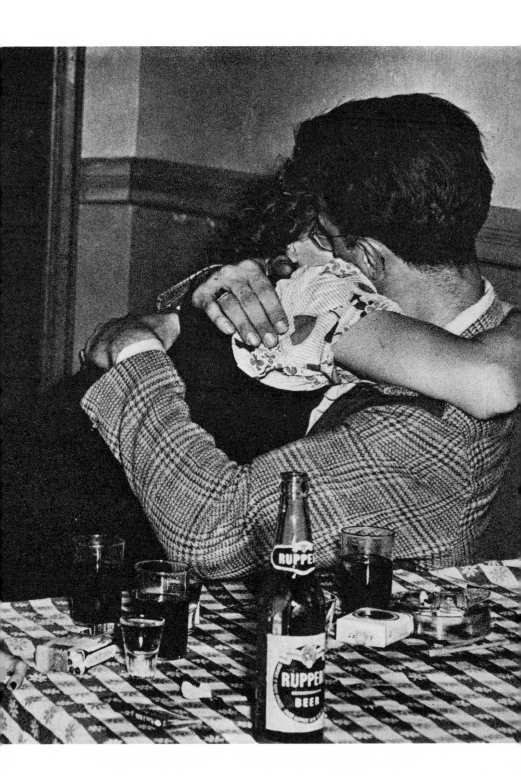

153

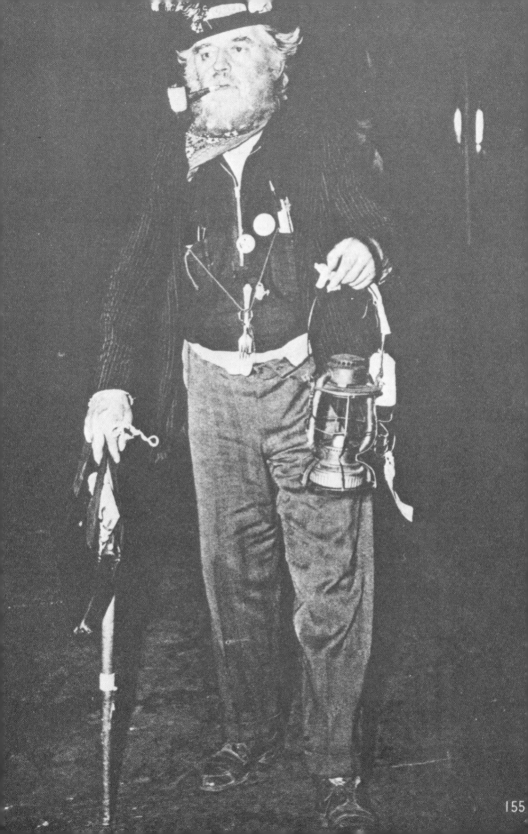

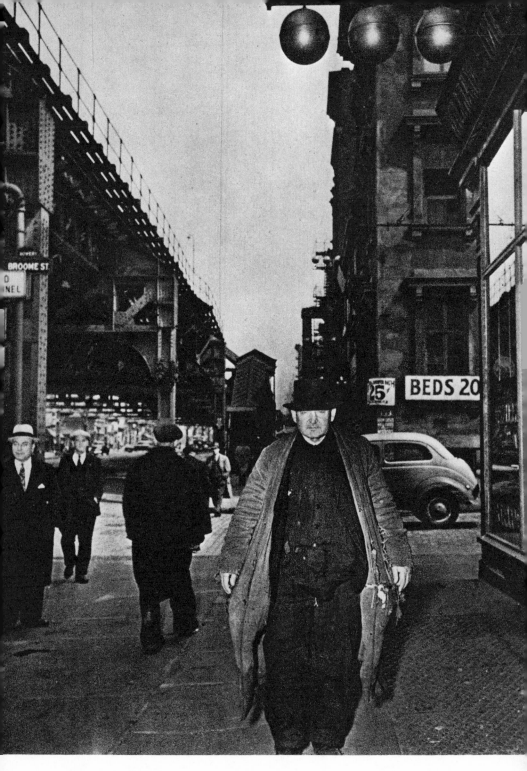

The Bowery by day . . . where only the El makes music.

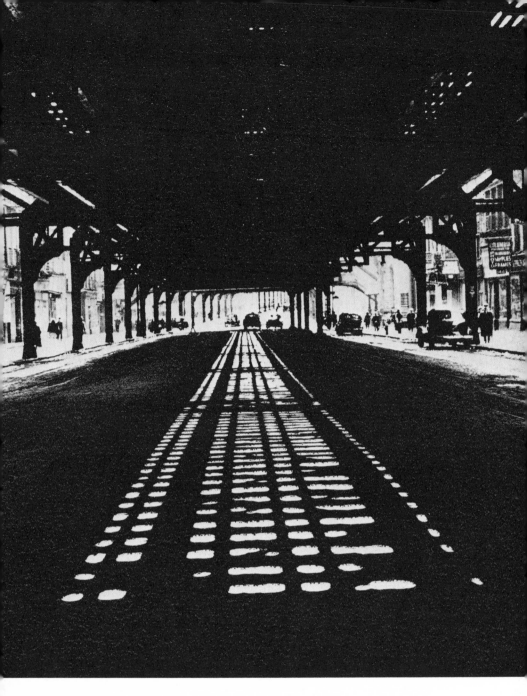

But there is beauty along this street of forgotten men . . . it lies in the pat-
terned black and gold along the trolley tracks where the morning sun
breaks through.

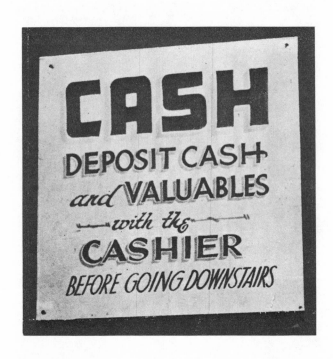

Not so long ago I, too, used to walk on the Bowery, broke, "carrying the banner." The sight of a bed with white sheets in a furniture store window, almost drove me crazy. God . . . a bed was the most desirable thing in the world.

In the summer I would sleep in Bryant Park. . . . But when it got colder I transferred over to the Municipal Lodging House. . . . I saw this sign on the wall there. A Sadist must have put it up. I laughed to myself . . . what Cash and Valuables . . . I didn't have a nickel to my name. But I was a Free Soul . . . with no responsibilities. . . .

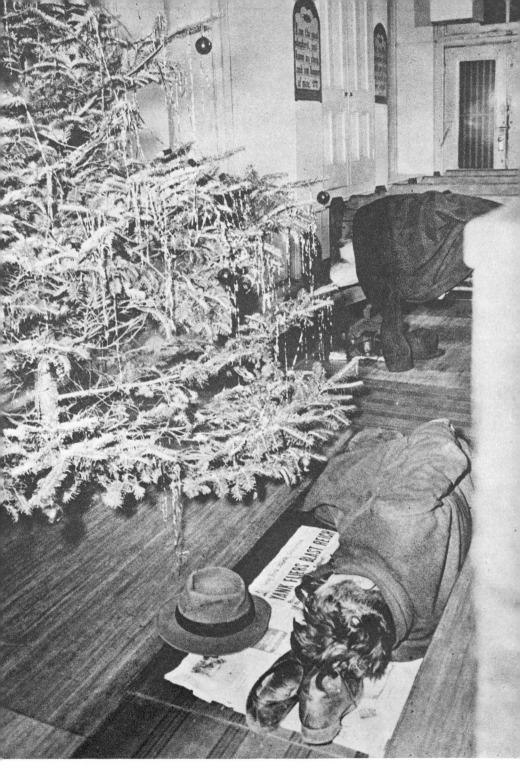

Slumber-time in a mission . . . it's Christmas.

11 "PIE" WAGON

Every morning the night's "catch" of persons arrested is brought down from the different police stations to Manhattan Police Headquarters where they are booked for their various crimes, fingerprinted, "mugged," in the rogues gallery . . . and then paraded in the police line-up . . . where they are questioned by police officials on a platform with a strong light on their faces . . . as detectives in the darkened room study them . . . and make mental notes for future reference. . . . The parade never ceases as the "Pie" wagons unload. I've photographed every one of importance from gangsters, deflated big shot racketeers, a President of the N. Y. Stock Exchange, a leader of Tammany Hall and even Father Divine, who kept muttering as he was booked, "Peace, brother, peace." The men, women and children who commit murders always fascinate me . . . and I always ask them why they killed . . . the men claim self defense, the women seem to be in a daze . . . but as a rule frustrated love and jealousy are the cause . . . the kids are worried for fear the picture might not make the papers. . . . I will say one thing for the men and women who kill . . . they are Ladies and Gentlemen . . . cooperating with me so I will get a good shot of them . . . the ones that "cover" up their faces are the Fences . . . Fagins and jewel thieves . . . who start crying and pleading with me not to take their picture . . . as their poor mothers will see it in the newspapers and it will break their hearts . . . they should have thought of that before they went into the crime business . . . I disregard their pleas and crocodile tears. . . .

The scum of the underworld arrives for the line-up . . . handcuffed to cops and detectives. . . . These are a couple of hoodlums who went around holding up small store keepers . . . from the line-up the next stop is the court . . . then Sing Sing prison. . . .

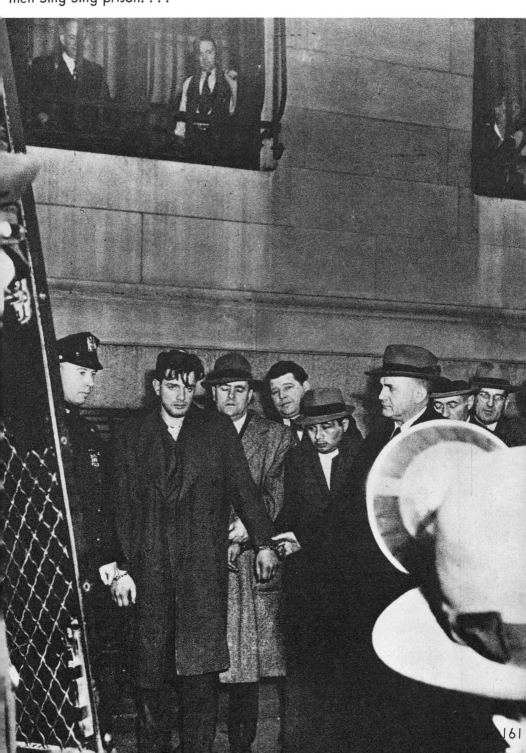

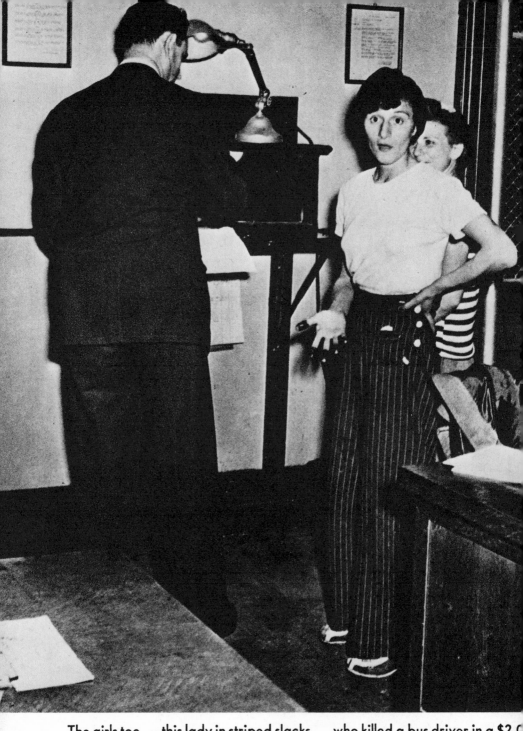

The girls too ... this lady in striped slacks ... who killed a bus driver in a $2.0
hold up ... is about to be fingerprinted and is amused by her finge
smudged with ink.

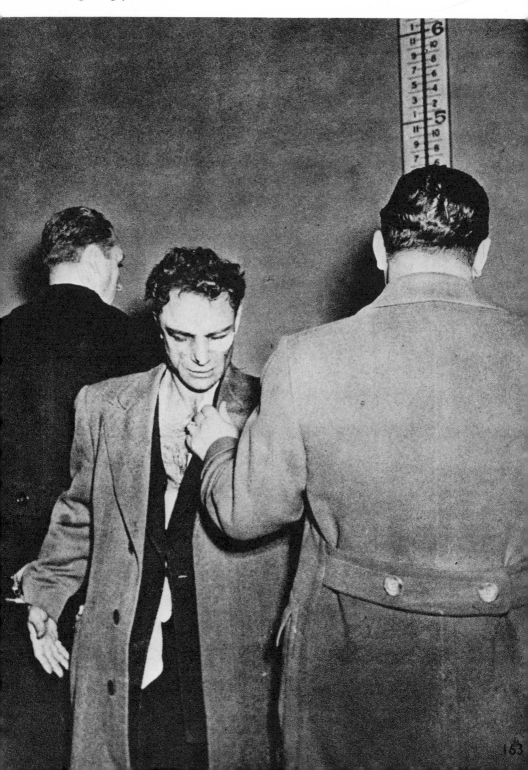

163

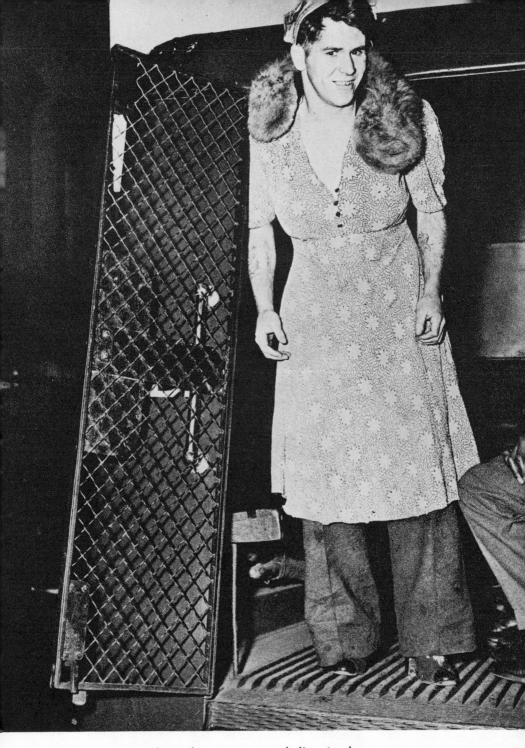

Burglar, who went around disguised as a woman. . . .

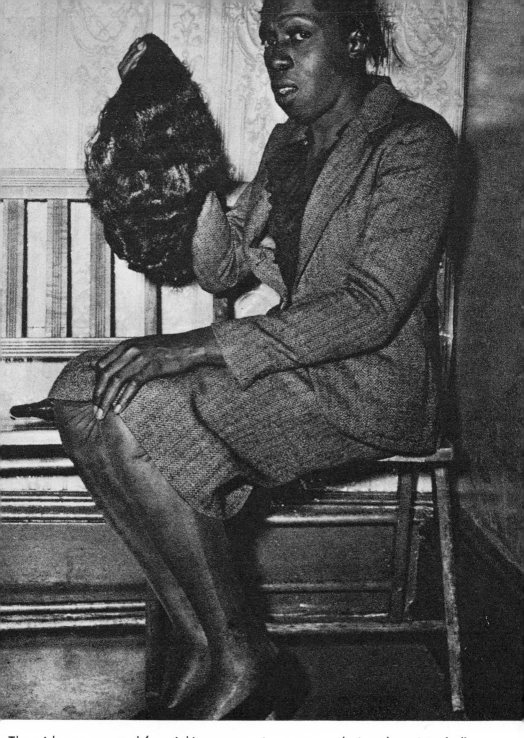

The girl was arrested for picking up service men . . . luring them into hall-
ways on the promise of a good time and then robbing them. When the police
matron examined her . . . it was discovered that the "Lady" was a man. . . .
Photo shows the prisoner removing the wig at the police station.

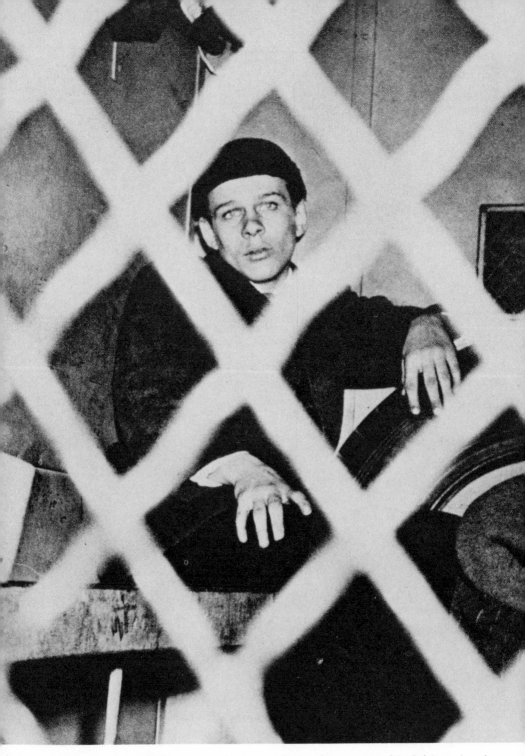

Sixteen-year-old boy . . . who strangled a four-year-old child to death.

He was booked for pouring kerosene on his wife . . . locking her in the bathroom, then setting her afire. . . .

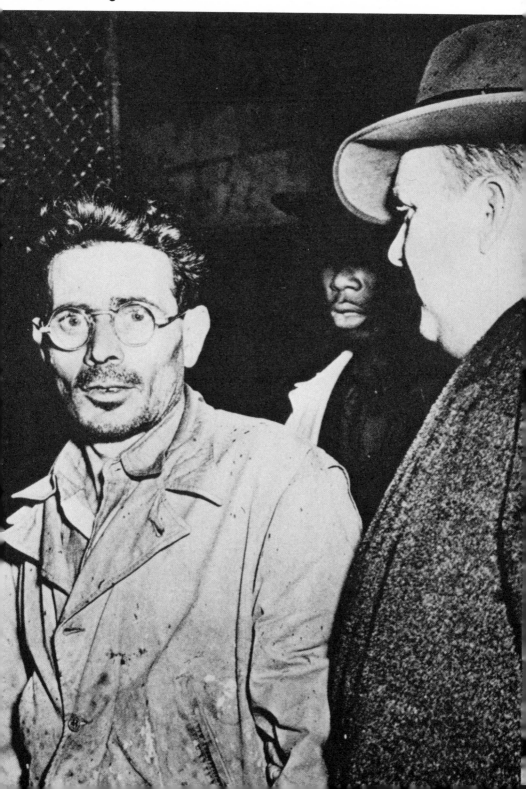

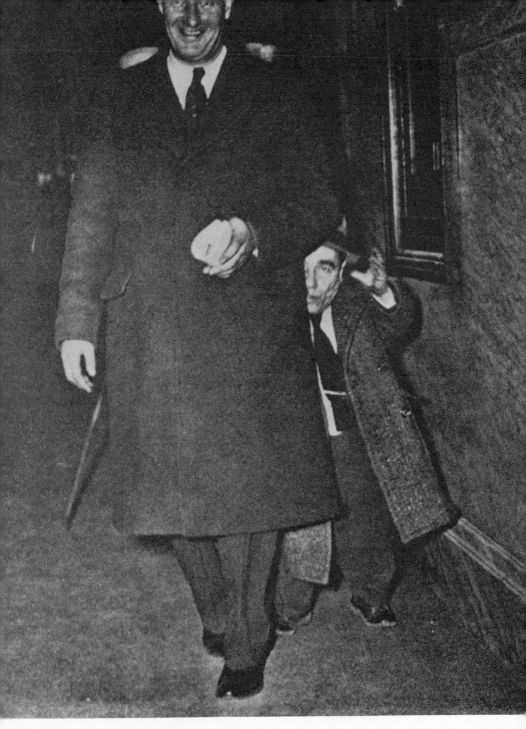

A New Low in Arrests

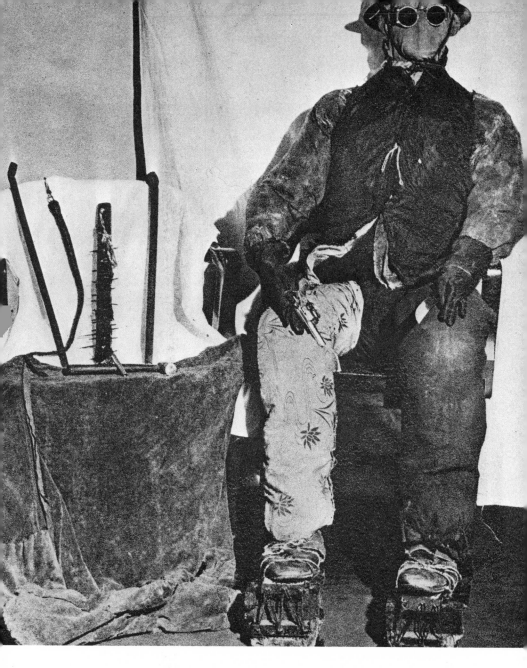

"Mugger" who worked in parks preying on couples. He wore this fantastic costume to scare his victims and also disguise himself . . . with his tools of trade . . . gloves . . . gun . . . iron bars. Around his shoes . . . he had blocks of wood wrapped in cloth to make him look taller and also to make his steps noiseless as he approached the couples to rob them. Usually they were so scared that they made no outcry.

These two guys were arrested for bribing basketball players . . . they gave me a lot of trouble as I tried to photograph them . . . covering up their faces with handkerchiefs.

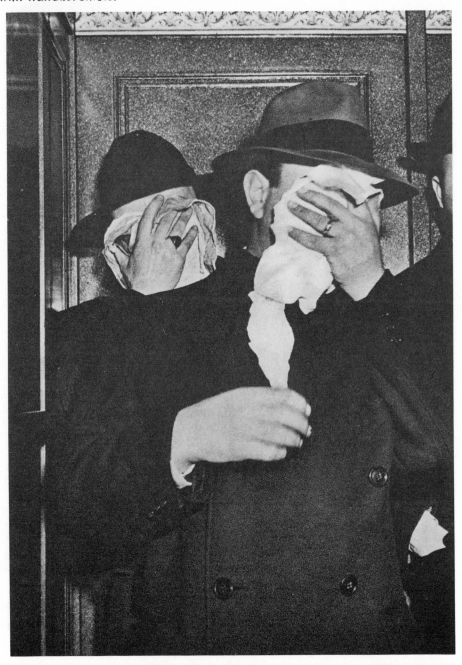

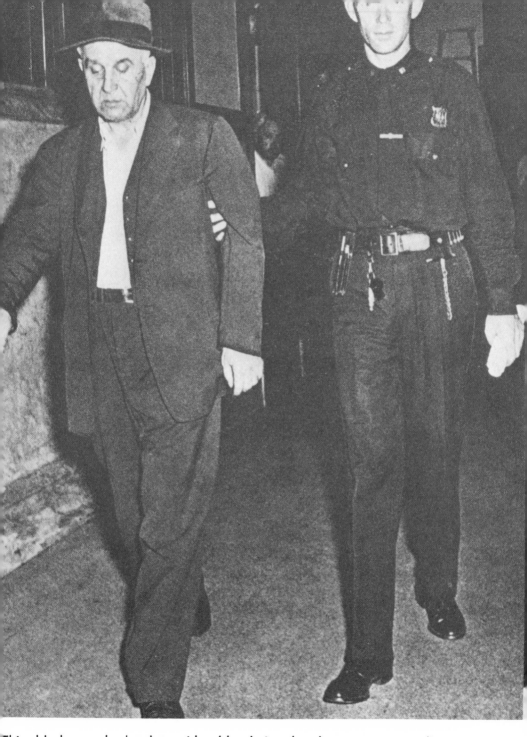

This elderly man had a date with a blonde in a hotel room . . . according to the police blotter, she "rolled" him for $450 so he knifed her to death . . . he did not try to "cover up" . . . as he couldn't see my camera because he was blind.

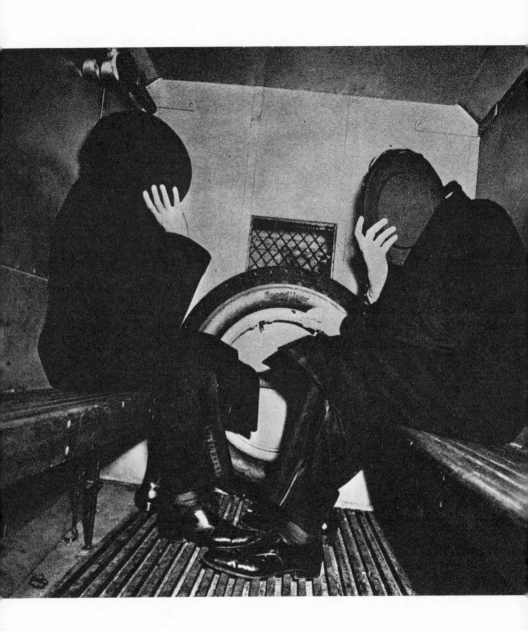

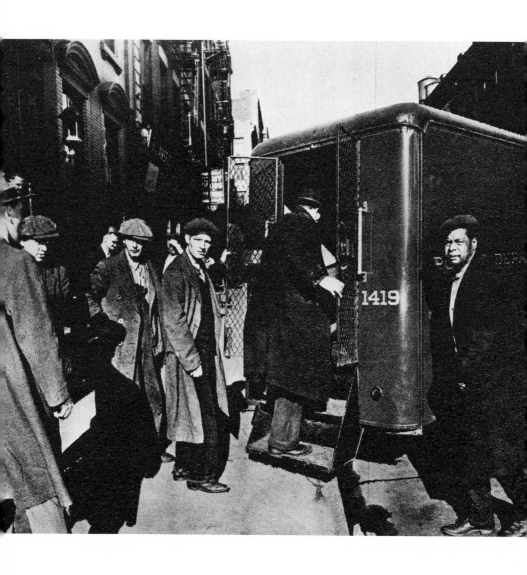

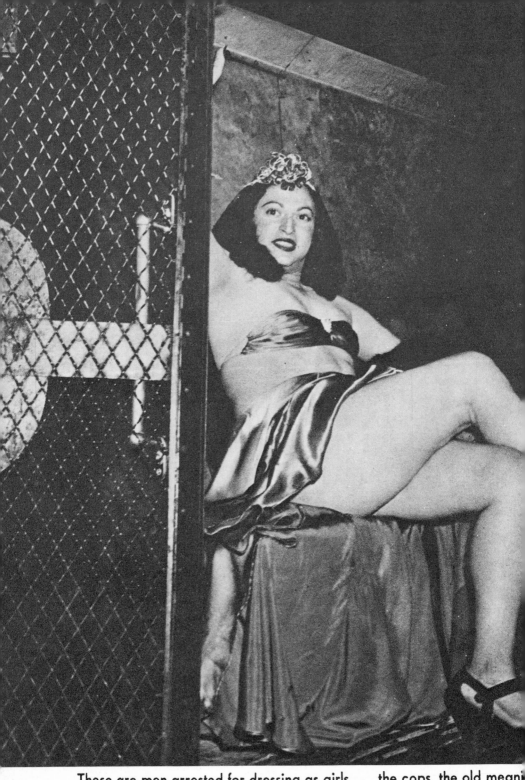

These are men arrested for dressing as girls . . . the cops, the old meani
broke up their dance . . . and took them to the Pokey.

174

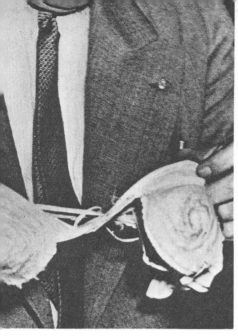
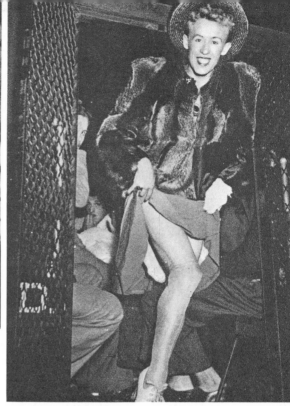

The Evidence
The "Gay Deceivers"

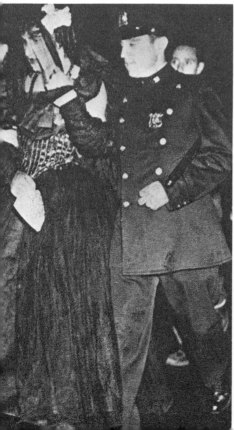
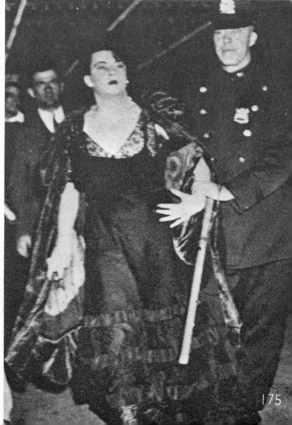

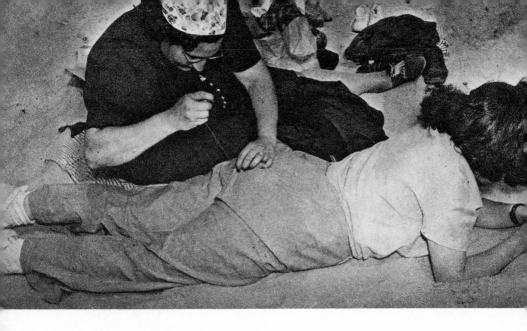

12 CONEY ISLAND

And this is Coney Island on a quiet Sunday afternoon . . . a crowd of over a MILLION is usual and attracts no attention (I wonder who counts them) . . . it only costs a nickel to get there from any part of the city, and undressing is permitted on the beach. . . . Some come to bathe, but others come to watch the girls. A good spot being the boardwalk. . . . Of the families, some manage to get through the day without losing their children . . . but the city is prepared and at the Lost Child Shelter the crying kids are kept cooped up behind a barrier of chicken wire till their parents call for them . . . also in this shelter are kept the peddlers who are arrested for peddling on the beach . . . seeing their merchandise melt, the peddlers give their ice cream to the kids.

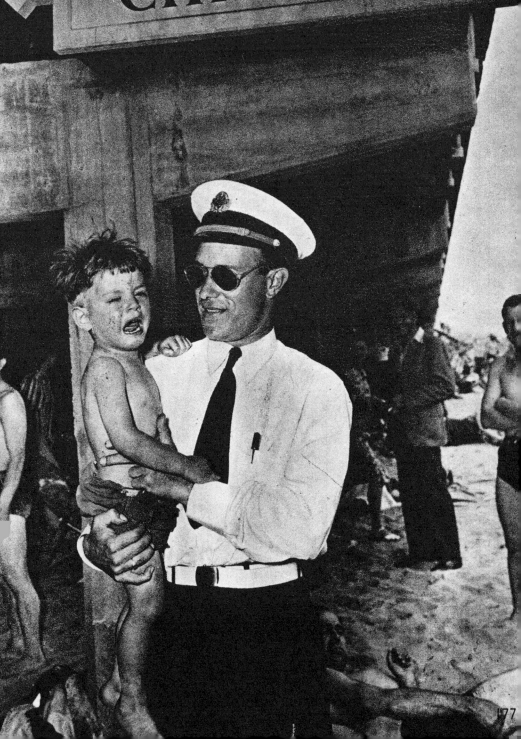

LOST CHILDREN

177

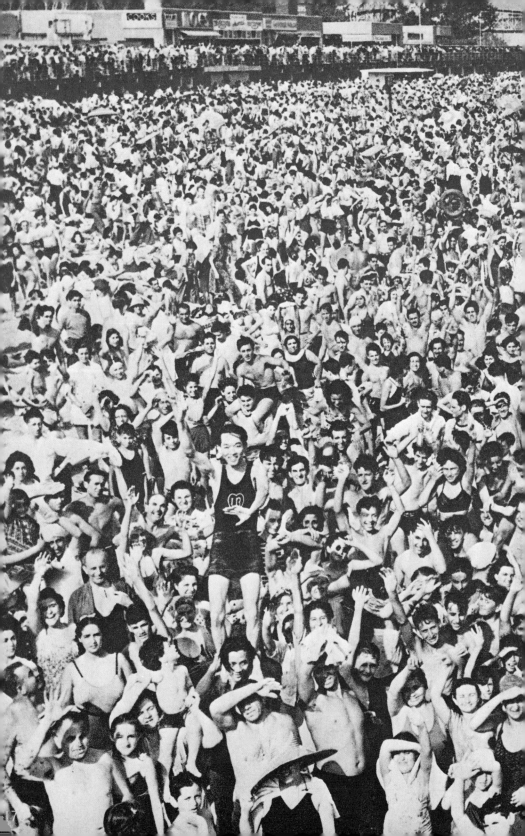

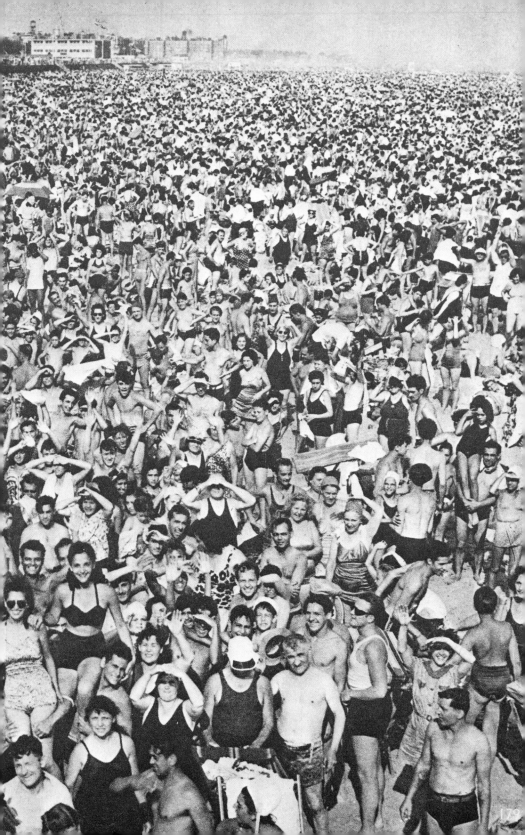

LOVEMAKING ON THE BEACH

It was after midnight and jet black. One of those nights when the moon forgets to come out . . . but the sweethearts like that. I took my shoes off so as not to get sand in them and went walking in my stocking feet on the beach, being careful not to bump into any couples. I wouldn't want to disturb them for the world. Once in a while I would hear a giggle or a happy laugh, so I aimed my camera and took a picture in the dark using invisible light.

It was so still. Once in a while there would be a flicker of a match lighting a cigarette. Love making is so exhausting . . . a happy kind of exhaustion . . . and a cigarette gives one a chance to rest up and hear the heartbeat of one's partner. . . .

I walked nearer to the water's edge and stopped to rest against a Life Guard Station look-out. I thought I heard a movement from above so I aimed my camera high and took a photo, thinking it was a couple who liked to be exclusive and do their love making nearer the sky. When I developed the picture, I saw that the only occupant on the look-out had been a girl looking dreamily towards the Atlantic Ocean. . . . What was she doing there alone among all the lovers? . . .

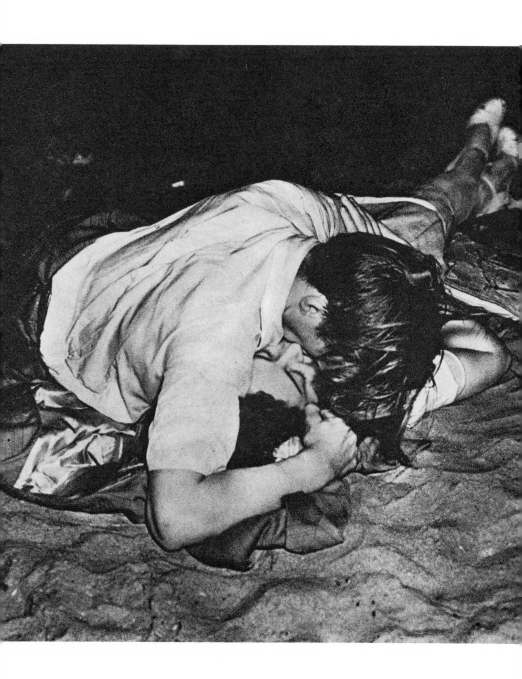

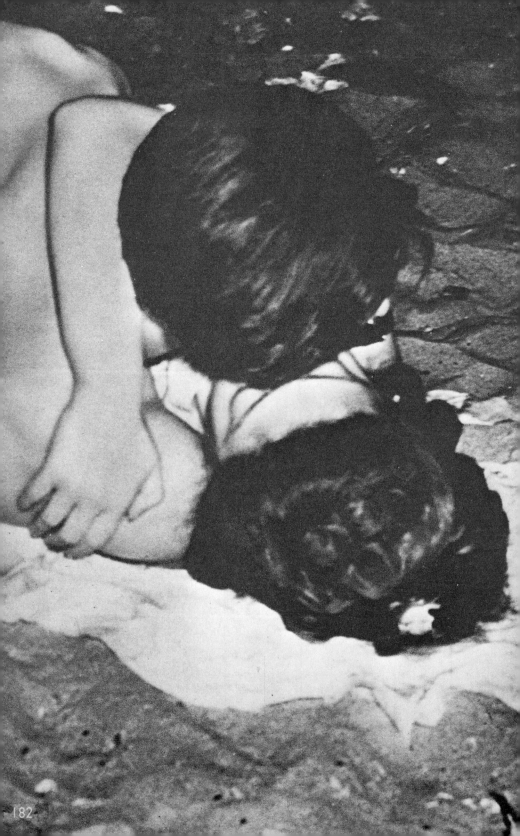

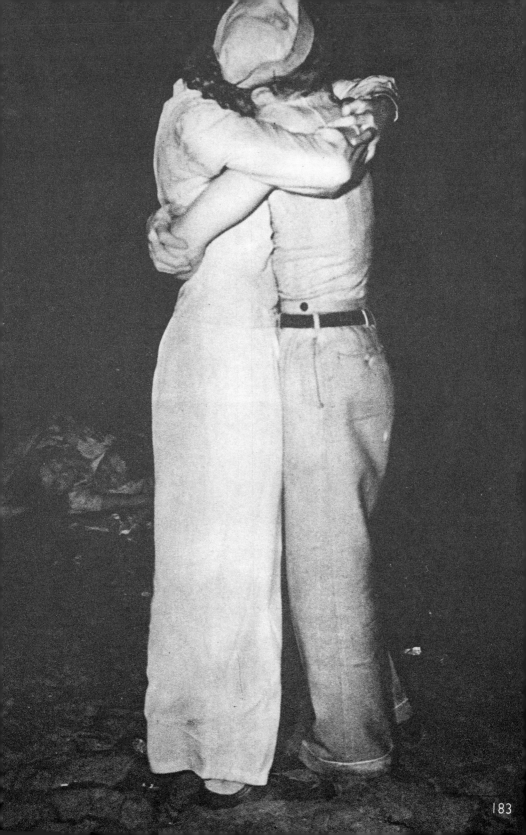

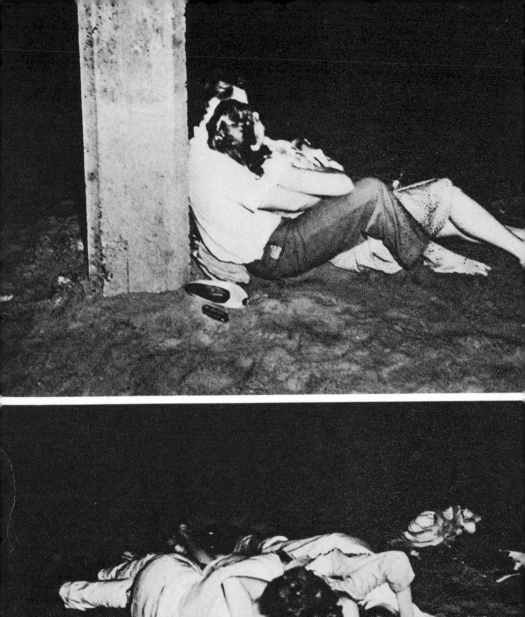
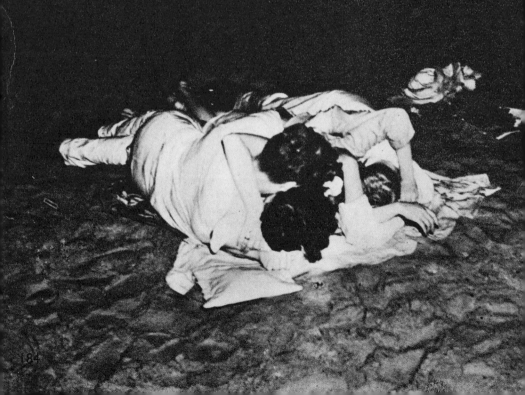

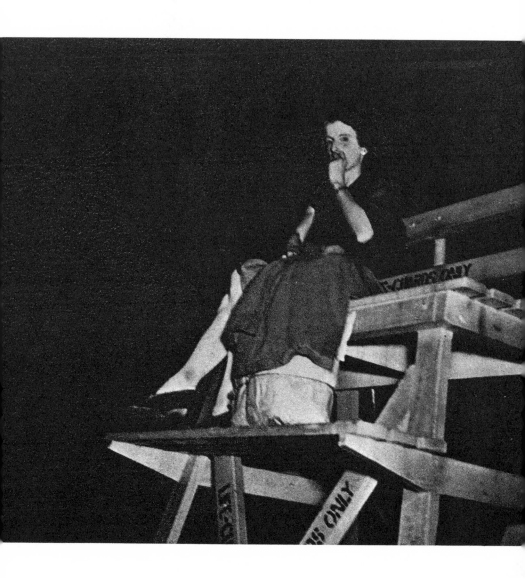

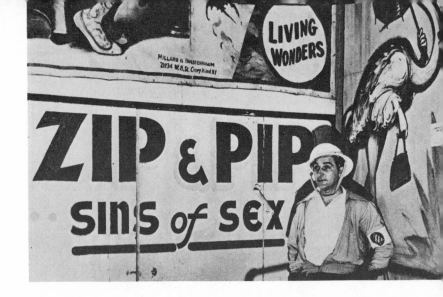

BLACKOUT

. . . Came the zero hour, 9 P. M. "Lights Out" and they did go out. . . . In Coney Island the freaks inside the museums got a well-earned rest . . . what with doing a new show every fifteen minutes inside, and the bally outside. . . . In Steeplechase Park the power was shut off the machine that throws up the girls' skirts as they pass. . . . At the Baby Incubator side-show the doctor was glad . . . he was slowly but surely being driven crazy by lady customers who kept pestering him with questions like "Where do you get the eggs from?" "How can I get a ticket for a premature?" "How can I have intercourse with this machine?" So Coney Island was dark. . . . But the saloons remained open for business as usual. The patrons remained inside in the dark . . . and kept ordering fresh drinks by lighting matches so the waiters could see them. . . . Someone sat down at the piano and started fooling around with the keys. . . . "Play *God Bless America*," someone shouted . . . the melody started on the piano and everyone joined in the chorus . . . but loud . . . people like to sing loud in the dark. . . .

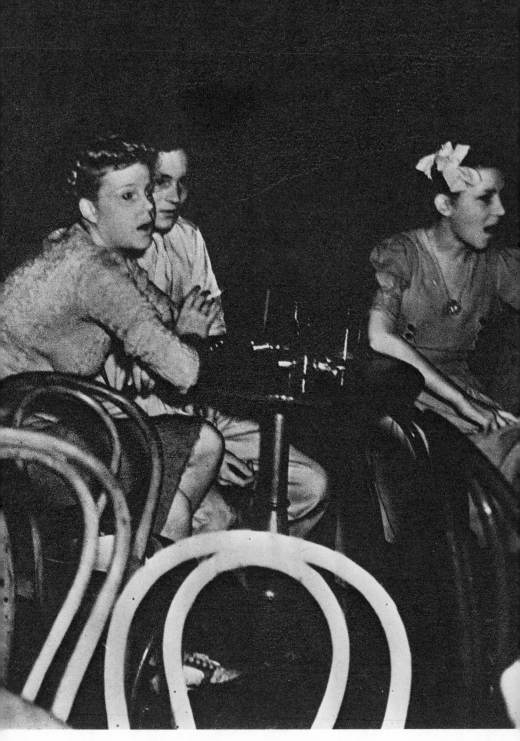

God Bless

America

13 HARLEM

Discrimination . . . that's the one ugly word for it. Books have been written and will continue to be written about this question. The solution I don't know, but here's one of the reasons for race riots . . . a poor white neighborhood. The occupants of the tenements are white bus drivers, street car conductors, elevator operators, shipping clerks, etc. . . . poorly paid white people, who themselves get pushed around all day by people they come in contact with in their work and by their straw bosses. So colored people, crowded out of their own colored sections, come looking for rooms in their neighborhood. So the ones that get pushed around themselves, now started pushing the others around by throwing rocks into the windows of the colored occupants.

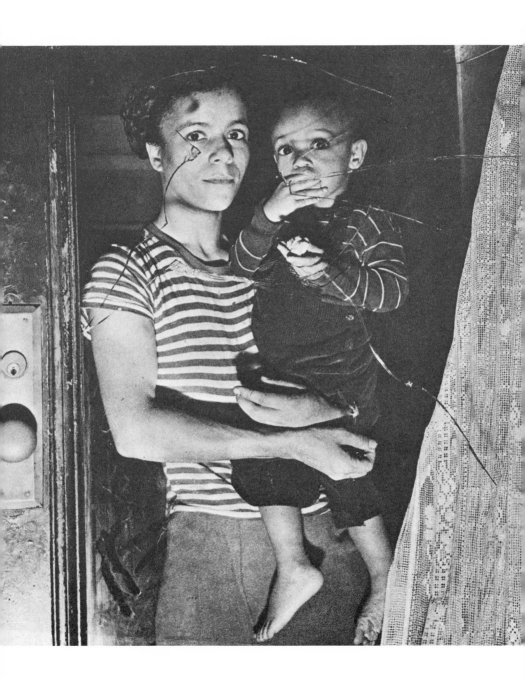

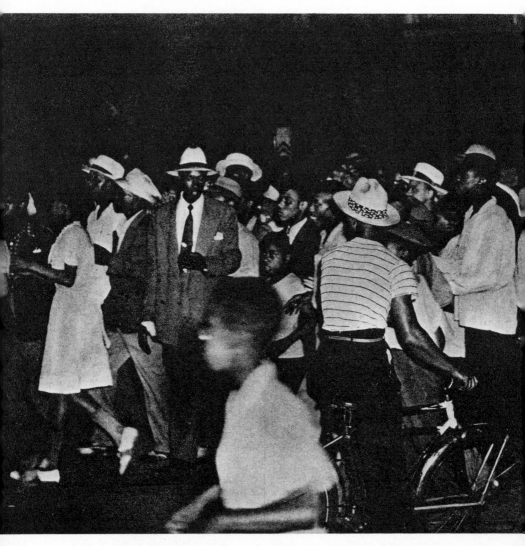

Here is the actual birth of a riot in Harlem. The streets are crowded with people, mostly young, wondering what the excitement is all about. . . .

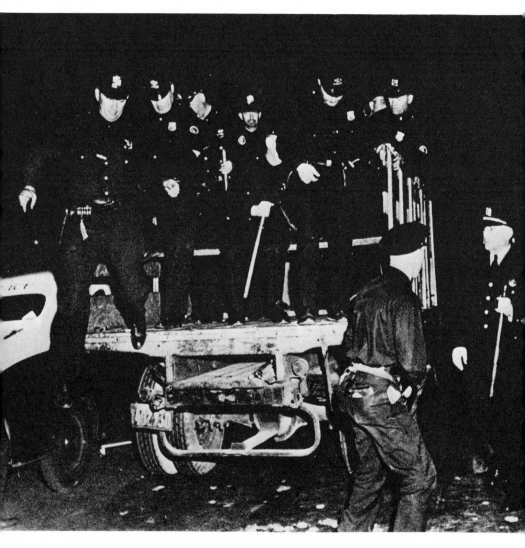

Then the hoodlum element takes over . . . looting and destroying. . . . The cops arrive in "sanitation" trucks . . . to clean up. . . .

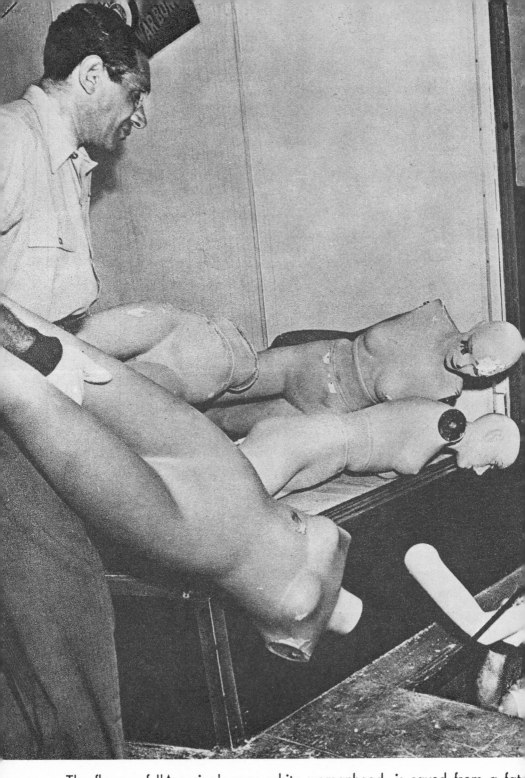

The flower of "America's pure white womanhood, is saved from a fate worse than.... Death."

The main street of Harlem . . . with not a store window undamaged . . . most of the stores in Harlem are owned by whites . . . they employ some colored help . . . because it helps business.

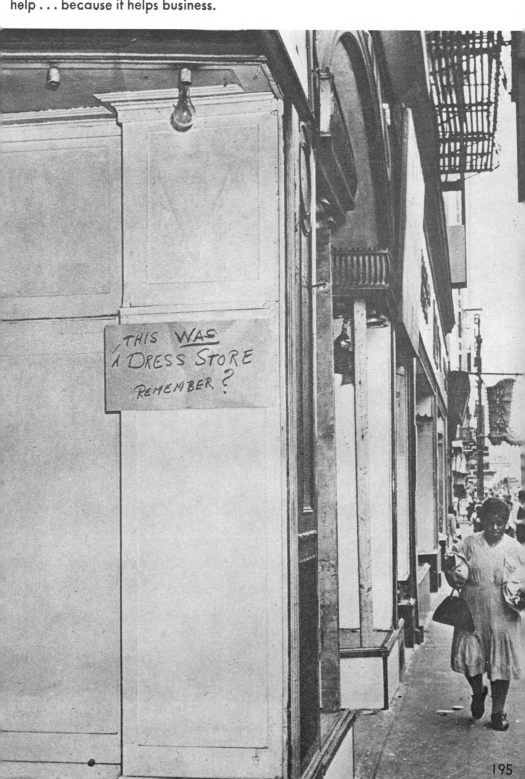

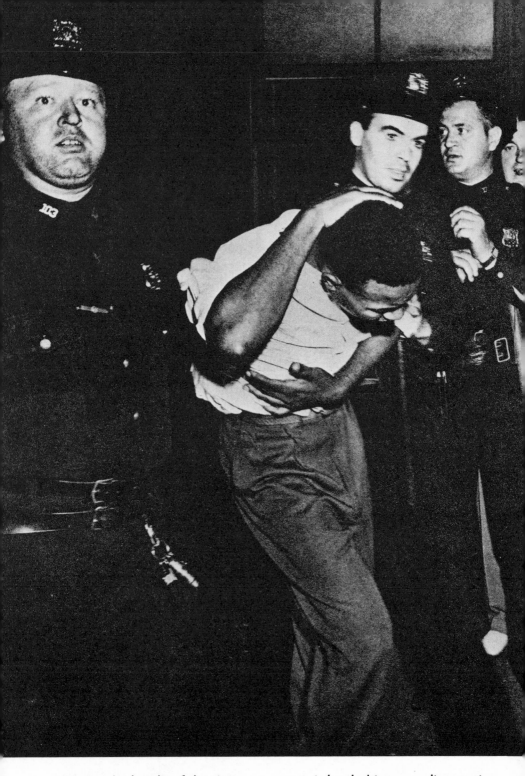

During the height of the riot . . . a negro is hustled into a police station. . .

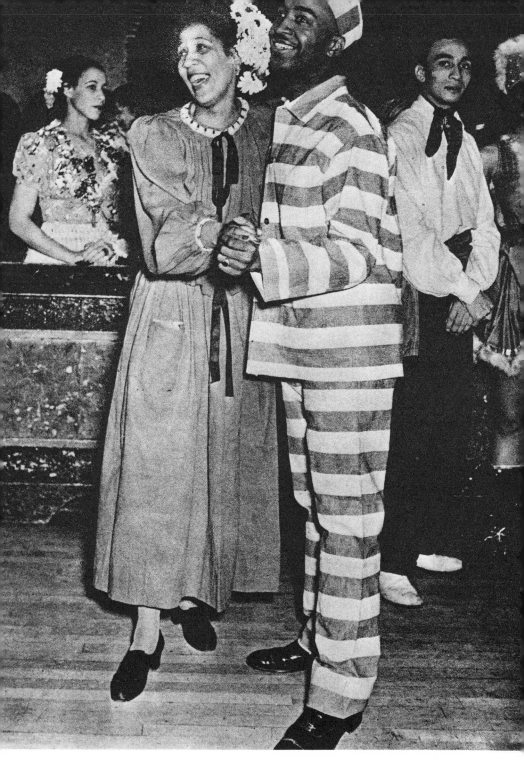

ut Harlem forgets its wounds quickly . . . on the surface anyway . . . at a
aturday night masquerade at the Savoy.

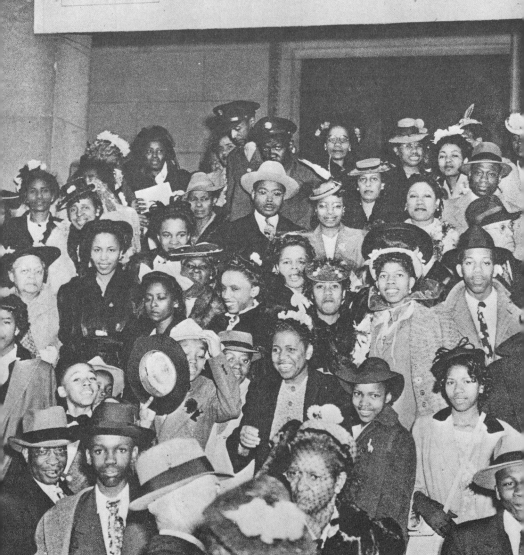

AFTER DEATH — WHAT?
REVIVAL MEETING

APRIL 10'
TO
APRIL 21'

Dr. H. H. COLEMAN DETROIT
PREACHES NIGHTLY
DR. O. CLAY MAXWELL, PASTOR

EVERYBODY
INVITED

This is Easter Sunday morning in Harlem . . . dressed in their best, they go
to church . . . the same as any other decent people . . . they're no different
. . . these are the people the papers don't write about or photograph . . .

I spotted this happy man coming out of church . . . he told me that he was a clothing salesman . . . and that every Easter Sunday he put on his full dress suit. . . .

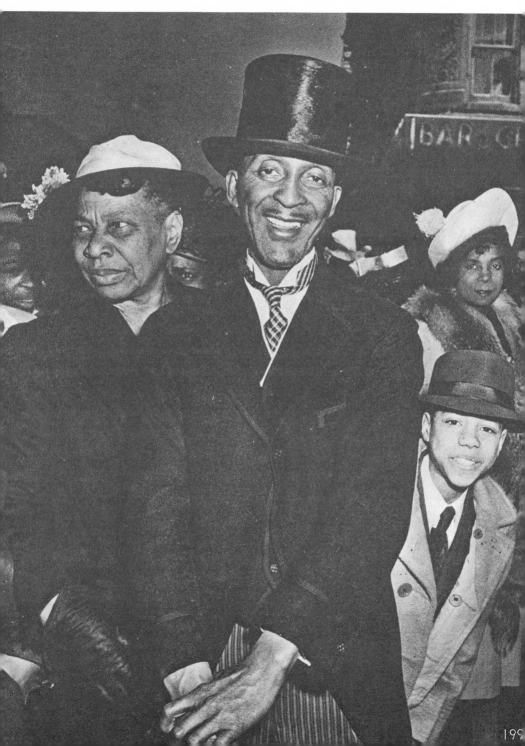

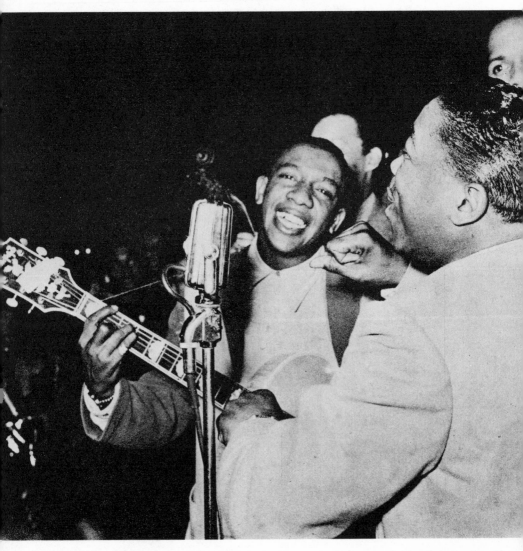

Now they are really in the groove again . . . whites and blacks mix freely again at the Savoy Ball Room. . . .

hey had been saving their pennies and nickels up for weeks . . . to buy
ckets for an excursion and a picnic. . . . A lot of counterfeit tickets had been
old . . . there was a wild stampede to get on the boat . . . scores of persons,
ostly women, were trampled to death. . . .

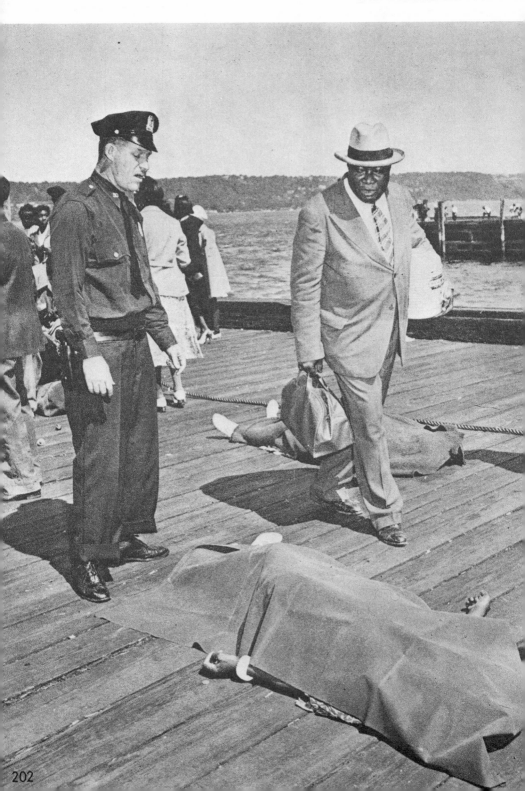

while the living cry....

14 PSYCHIC
PHOTOGRAPHY

A burglar is caught by
detectives in a window
of a store.

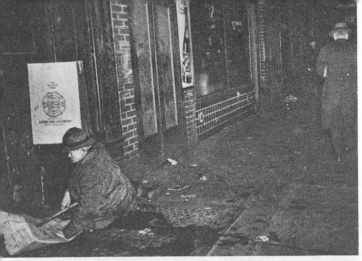

For the first time, an accident is photograph[ed] before and after it happened.

A man is seated on the sidewalk taking it easy. . . .

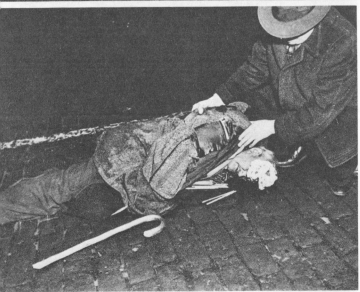

He gets up to cross the street and is hit by a taxicab. . . . The poor man was a peddler of pencils. His cane was broken and his stock of pencils lie beside him.

A passerby has put a handkerchief to his forehead to stop the flow of blood.

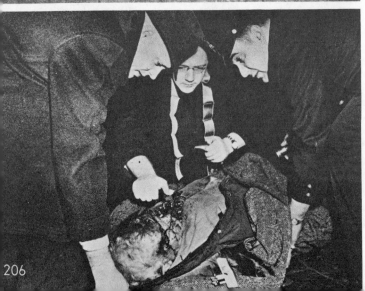

A passing priest gives the injured man the last rites of the Church.

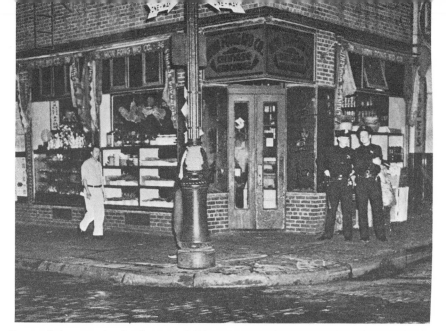

Peaceful scene in the heart of Chinatown. The cops who always patrol the beat in pairs there think I am crazy . . . because I am taking their picture. . . .

Right after I took the photo above . . . the street blew up . . . the water main pipes broke . . . the gas main caught fire . . . followed by an explosion . . . five hundred tenement dwellers in the block were driven from their homes.

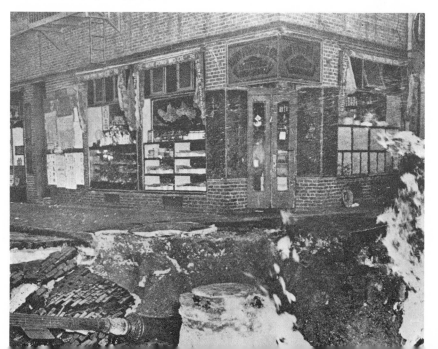

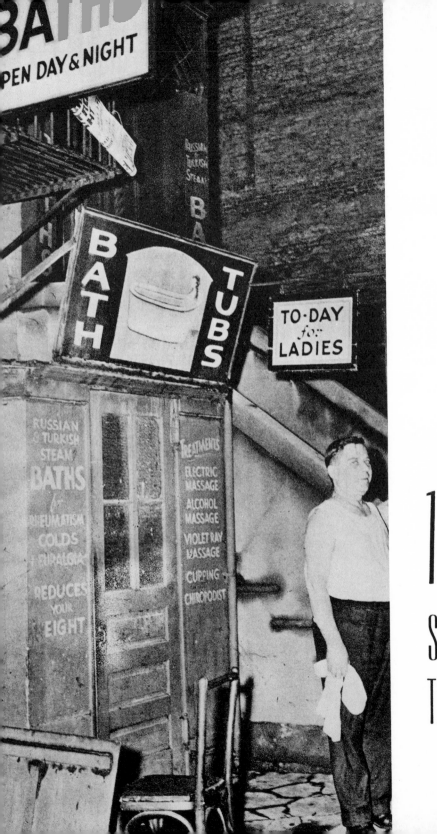

15

SIGNS OF

THE TIMES

AFTER

BLACK EY SPECIALIS

BARBER WANTED

ALE ON IN UP GIRLS

RSE-FLESH OLD HERE

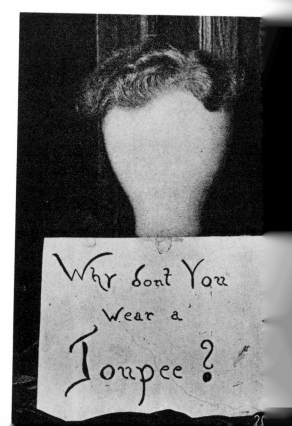

ON CORN SALVE CAN GET AT OCK DRUG STORE 6 E 14TH St.

Why dont You wear a Toupee?

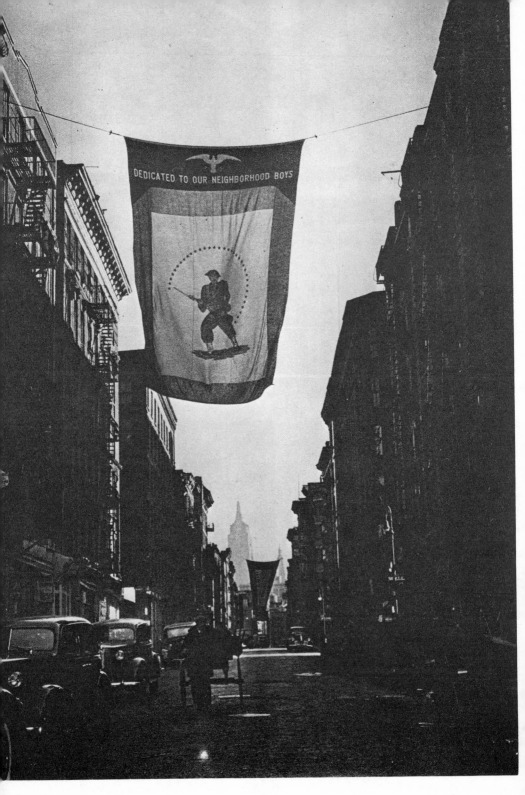

DEDICATED TO OUR NEIGHBORHOOD BOYS

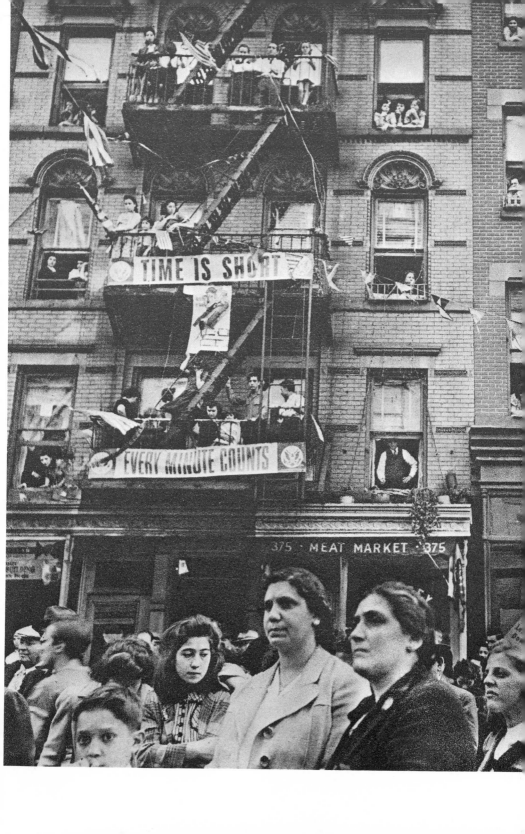

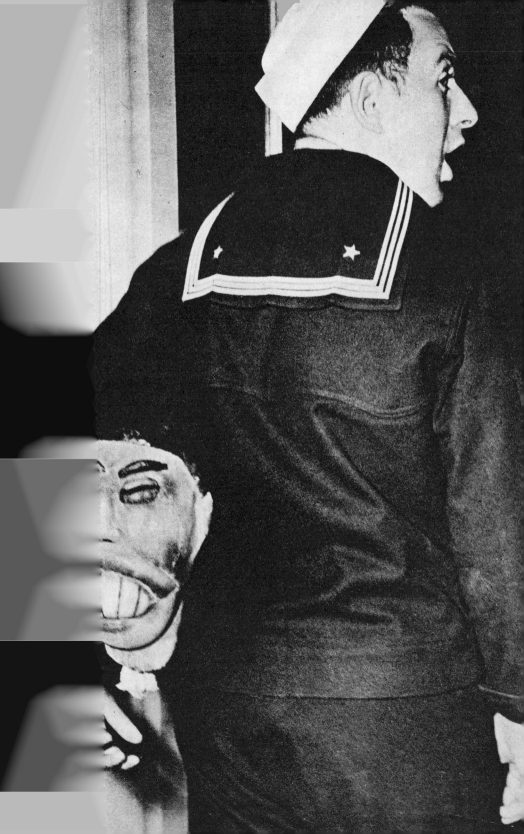

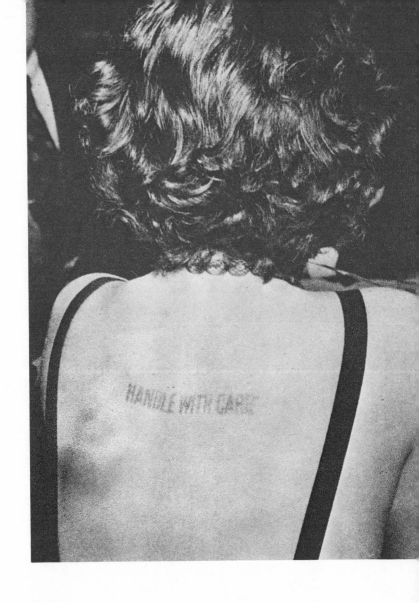

16 ODDS AND ENDS

Maybe I should have included these with the Signs of The
Times Series . . . anyway they're a couple of cuties at an
artists' ball . . . but is this art?

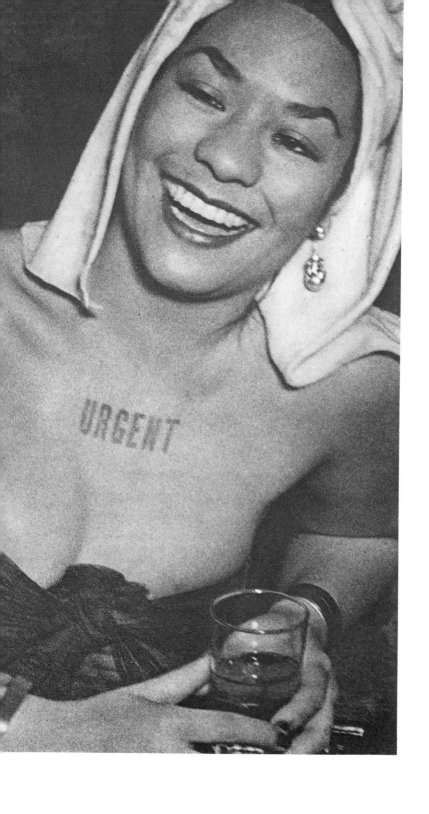

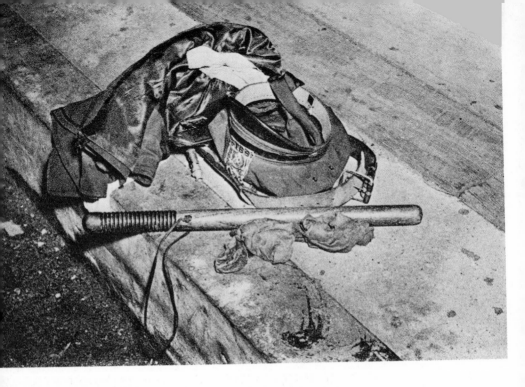

Life's problems become too complicated for some people . . . so they jump into the river. Cops in cruising cars hear more than just what comes in over their radios . . . this cop hears a splash . . . he jumps out, takes off his hat, his coat, his shoes, then his pants which he rolls up in a bundle to hide and also to protect his gun . . . places all of them on the edge of the pier . . . and jumps into the icy water in his shirt and underwear, cursing. After a rescue the cop always has to take the trip to the hospital along with the would-be suicide to get thawed out . . . they have equally good chances of catching pneumonia.

The radio cars cruising the water-front are well stocked for rescue work . . . they carry ropes . . . life preservers . . . everything except K rations and a Bible.

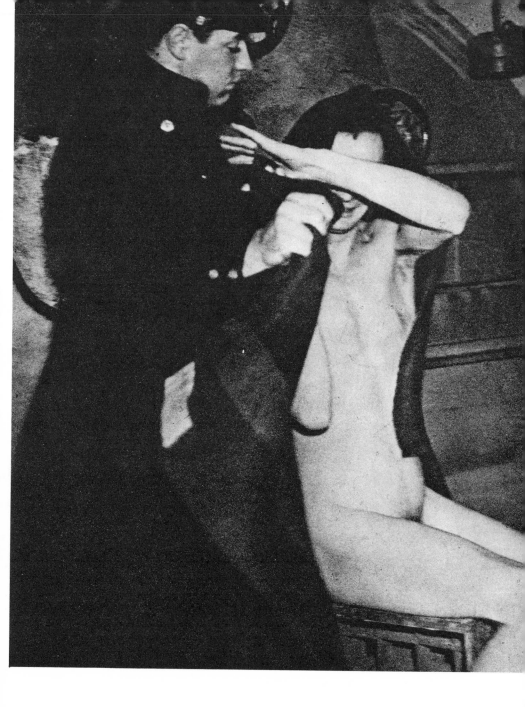

This is a high class pooch . . . you see them on Park Avenue, Fifth Avenue, Central Park West, on streets where the better classes live. . . . Well fed . . . well trimmed and house broken . . . except on the public streets. . . .

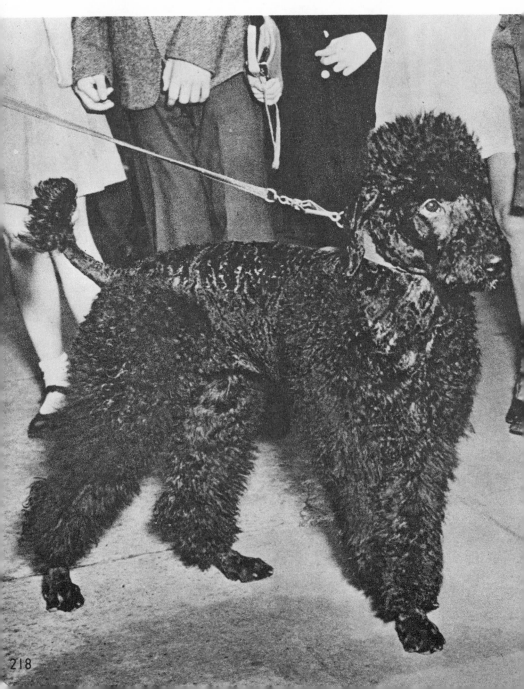

And this is a baby abandoned in a furnished room by its mother . . . still crying, it was removed to the Foundling Home. . . . The baby was given a number . . . business is good at the foundling home . . . this one's number was past the one thousand mark.

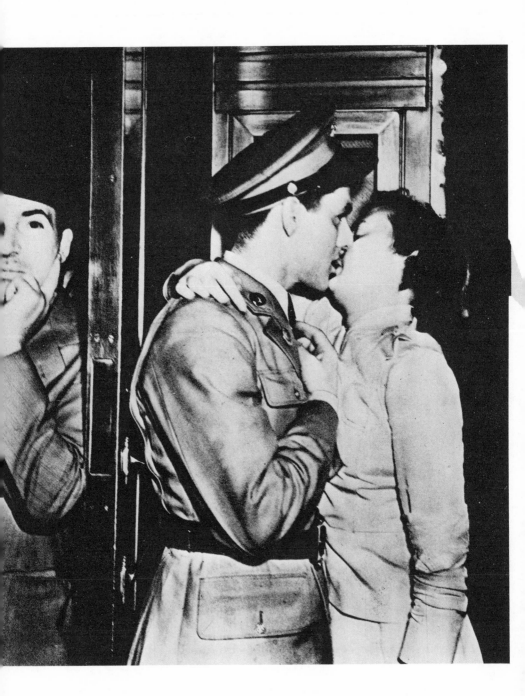

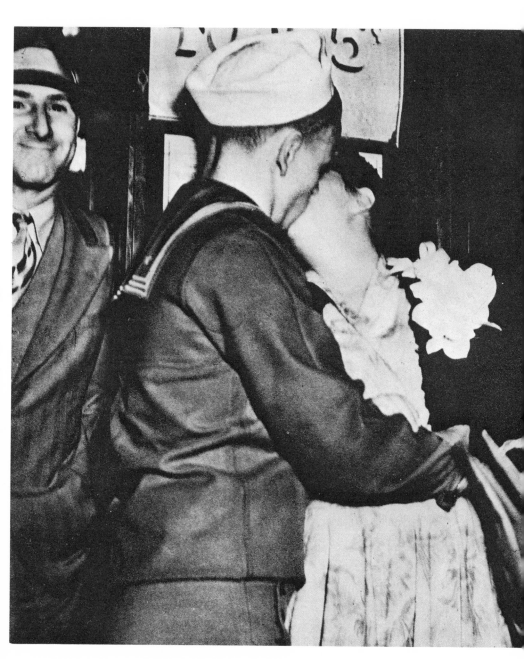

The couples they love, to love.

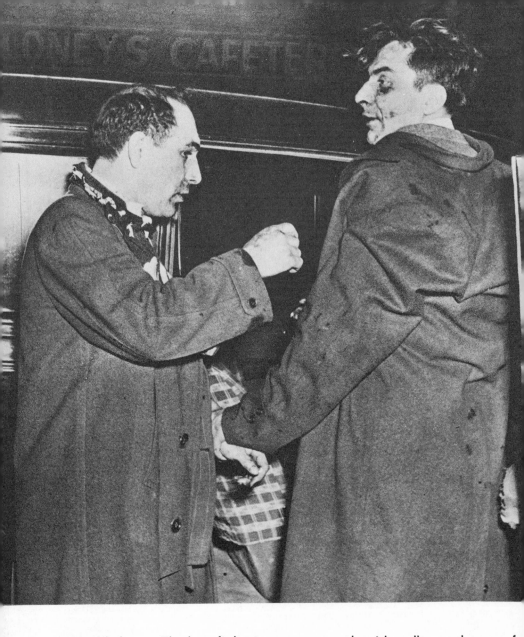

And fight. . . . The best fights in town are on the sidewalks . . . they are fr
for the spectators to enjoy . . . that is till a cop arrives to break it up . . . b
the cops always arrive when the fights are over. This was a little argume
outside Madison Square Garden. It was a much better fight than one se
inside on Friday nights. . . . I don't know what they were fighting about bu
guess it was nothing trivial.

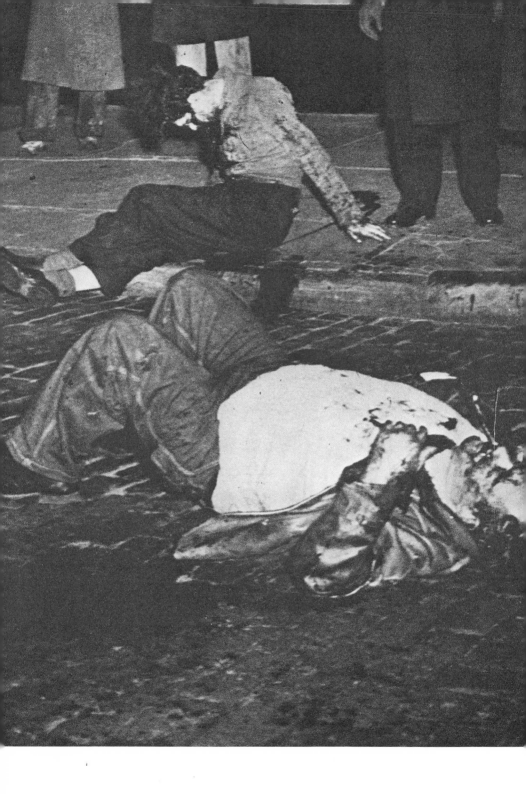

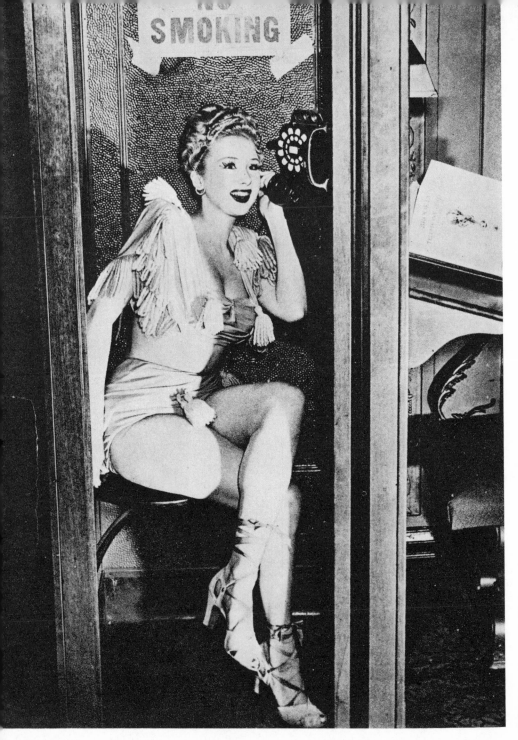

A phone booth is a handy place to make a date.

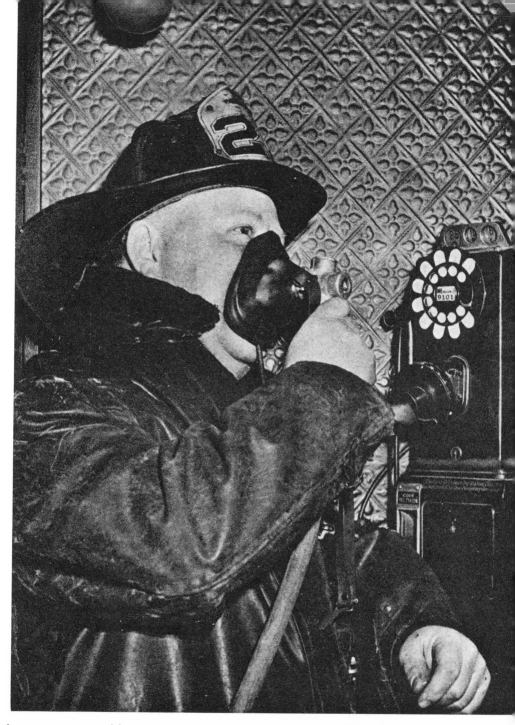

Also to get some life-saving pure air into one's smoke-filled lungs via an inhalator.

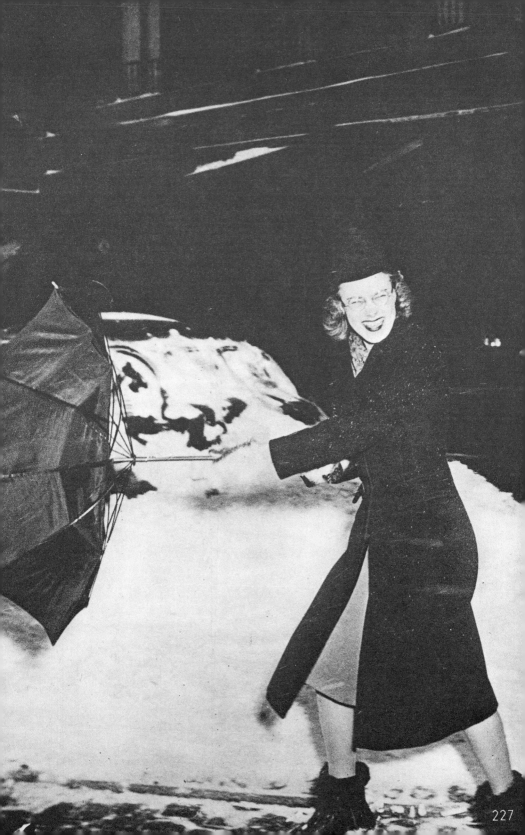

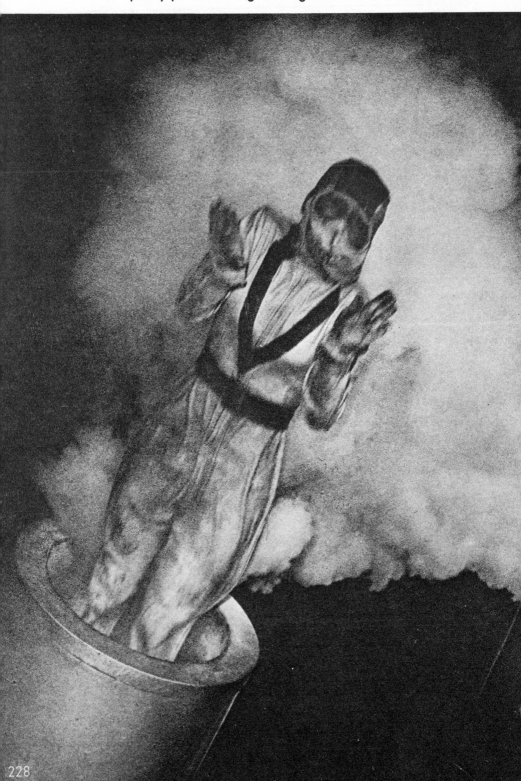

EASTMAN—SAFETY—KODAK 86

This is an unexposed film of *Greenwich Village* because nothing ever happens there. . . . The artists have all gone in for still life . . . because the models are working in defense plants and eating regular. . . . A girl who doesn't wear mocassins and slacks is considered anti-social . . . the favorite meeting place is at the "Cercle de la Paix"—the circle of peace—that's *Washington Square Park*. . . . When it gets colder the rendezvous is at the Waldorf Cafeteria at 6th Avenue and 8th Street. . . . You can tell the artists by their berets and beards . . . and frustrated looks.

This is Joe McWilliams, professional anti-Semite and Nazi lover. . . . Don't make any mistake . . . that's handsome Joe at the top of the photo . . . looking toward his future. . . .

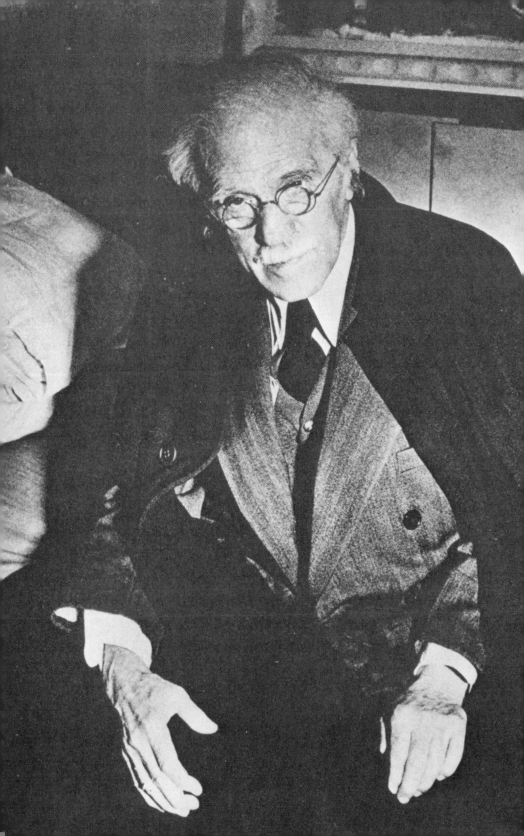

17 PERSONALITIES

ALFRED STIEGLITZ

Alfred Stieglitz became famous both in Europe and America
as the master of the camera, and what did his fame get him?

On Madison Avenue in the fifties . . . morning . . . noon . . .
and night a lone man walks the streets. He wears a black
cape (Loden cape bought in Tyrol, Austria), white shirt, black
tie (not bow), black hat. No one pays any attention to him. A
few kids turn around. Just another character. I've noticed
him many times . . . walking as if in a trance. I was afraid to
disturb him . . . finally I walked up to him and said. . . .

"You Stieglitz? I'm Weegee. You may have read about
me in magazines, or seen my pictures in *PM*."

He stared at me as if I had waked him from a dream and
told me that he never read about other people or himself. I
apologized for the intrusion and told him that for a long time
I had wanted to meet him. He became gracious and invited

me to come up to his studio but first he stopped at a drug store, where he left a prescription to be filled . . . then up to No. 509 Madison Avenue where we took the elevator to the seventeenth floor. We stopped at a door. On the glass was painted AN AMERICAN PLACE. It wasn't locked and we walked in. The place was fitted up as a gallery, with paintings hung on the walls . . . there was a smell of disinfectant like in a sick room.

In the back of the gallery, in a cubbyhole, Stieglitz slumped on the cot, half sitting and half lying, too exhausted to take his cape off. That was his home. We started to talk. I was at last talking not only to the most famous photographer in the world, but one who had also sponsored painters and sculptors . . . unknown once, but famous now.

I had so many questions to ask . . . the hours went by fast . . . (I was wondering if I was going to find a ticket on my jallopy parked at the door.) Stieglitz pointed to the 'phone near the cot. . . . "It never rings . . . I have been deserted . . . the paintings on the wall are orphans . . . no one comes up to see them." I switched the talk back to photography. Was he a success? No, he was a failure. What about the photographers he had known and started and helped? They were successful . . . why? . . . because they had wanted money and were now working for the slick-paper magazines . . . because they were politicians and showmen who knew how to sell themselves. As for himself . . . he hadn't made a photograph for the past ten years . . . had never used the products of one company, because they had advertised, "You push the button. We'll do the rest. . . ." . . . that slogan was a bad influence on photographers because a picture needed careful planning and thinking and could only be captured on film at a certain fleeting fraction of a second . . . and that once that

passed, that fraction of time was dead and could never be brought back to life again . . . that he had never compromised with his photography, for money or to please an editor. One had to be free to do creative work.

What about his influence on American photographers? Could he teach or influence them to do the same things he had accomplished? The answer was a firm no . . . I thought of a lecture which I recently gave at the Museum of Modern Art . . . and the questions which were asked of me there. I thought perhaps Stieglitz would have the answers.

He also told me that he was eighty-one years old. That the happiest time of his life was spent in Berlin at the turn of the century . . . it was free then and that when he returned to America he used to cry himself to sleep every night for two years thinking of the dirty streets here.

I asked Stieglitz how he lived and payed the rent. He told me that he had a private income of eighteen hundred dollars a year. That three hundred and fifty dollars went for income tax. (Not that he had to pay it but he felt that the government needed the money worse than he did), that the rent money and expenses, about four thousand dollars a year for the studio, was contributed by the artists when they sold the paintings which were on exhibit. . . . That few paintings were being sold now . . . that the rent was not going to be ready and he was afraid he was going to be dispossessed.

Suddenly he slumped over in pain. "My heart, it's bad," he said in a whisper as he slumped over on the cot. I waited till he recovered then left quietly . . . wondering if that elusive fame I was after was worth while.

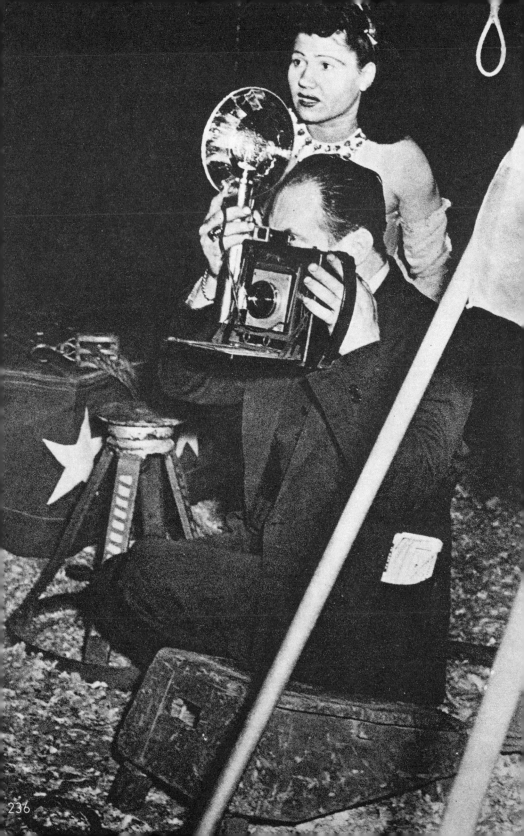

PAT RICH

At the Ringling Brothers and Barnum and Bailey circus at Madison Square Garden, I came across Pat Rich, staff photographer of the *Police Gazette*. This is my favorite magazine . . . as I like to look at the pictures of the beautiful showgirls and am always answering the advertisements of the places that sell Magic Dice and marked cards that make you lucky in games of chance.

I asked Pat, who is known as the Virtuoso of the Cheese Cake (leg) photo, to tell me some of the secrets of his fascinating profession.

Pat told me that his editor was a woman . . . that all the pictures he took were sent down to the Post Office in Washington, D. C. to be censored. . . . (The same as they do with the war pictures from the battle fronts); that the high officials of the P. O. put crosses with a red crayon pencil on the parts of the pictures that are taboo and are to be eliminated; that the photos were then given to an artist who painted panties over the tights and also painted out the belly buttons. After that the pictures were sent down to a bishop in Davenport, Iowa for a final OK. After that the magazine felt safe in running the pictures and not getting into a jam with the Post Office as *Esquire* did.

I asked Pat what was the greatest photo he had ever taken. He told me that at an ice skating carnival one of the girls had slapped another one in her behind . . . always on the alert, he snapped the shot. It created a sensation. Readers wrote in asking for more pictures of girls being slapped on their fannies . . . they liked that . . . but other subscribers keep on writing, complaining about the missing belly buttons . . . to Pat they are morons. Pat continued, "Take a dozen cameramen, send them out to photograph showgirls . . . seven-tenths

of them will come back with lewd pictures: they lack the fine art of seeing and getting the beauty that's there . . ." that the difference between him and other photographers was the difference between a John Murray Anderson, who also saw beauty, and a burlesque producer."

Pat showed me a 1940 copy of the *Police Gazette* with a layout of pictures of showgirls from the circus. "Look at these photos, they are works of art . . . but I wouldn't dare take pictures like that today . . . they show too much." As I left, Pat was wandering all over the garden in search of the body beautiful . . . with panties but minus the belly button.

18 CAMERA TIPS

The only camera I use is a 4x5 Speed Graphic with a Kodak Ektar Lens in a Supermatic shutter, all American made. The film I use is a Super Pancro Press Type B. I always use a flash bulb for my pictures which are mostly taken at night. Even on the few occasions where I have made shots by daylight, I still use a flash bulb. I also use a Graflex flash synchronizer and the exposure is always the same, 1/200 part of a second stop F.16, that is, at a distance of ten feet. When I am making closeups at six feet, with the light from the flash bulb closer to the subject and hence stronger, I step down to F.32 . . . which compensates if I am a little off in my guess of the distance.

Guess focus troubles a lot of beginners, but on a story where lots of things are happening fast and furiously, one has no time to look through the ground glass to focus . . . or even to use the range finder . . . and besides, it is pitch dark. I keep my camera set at ten feet, which takes care of most pictures. For close-ups I quickly change the focusing scale to six feet by the light of a small pencil flashlight which I always carry with me. With concentration on six and ten feet, and a lot of practice, one can guess these two distances. Don't try to guess focus the markings in the scale . . . no one can do that . . . just practice six and ten feet, but do your practicing at home at your leisure . . . you won't have time on a story. Editors demand and expect to get needlesharp photographs.

Captions are important too. Editors want to know who . . . when . . . where. . . . Get all the information you can, don't be

afraid to ask questions . . . be curious. The readers always are, and even a guy who has just committed a murder will give his name and address . . . and often try to justify his crime.

How does one get started? Photographers are always writing to ask me this. It's not hard . . . after you have shot your pictures, take them to the city editor of your home town newspaper, or if the pictures are of more than local interest, mail them special delivery-air mail to *Life* magazine if there is not a local *Life* office in your town. If your photographs are accepted it means national recognition for you and a fat check besides . . . and moreover, even if they reject the photographs of a beginner, they will offer hopeful and constructive criticism.

I work alone and I don't use . . . extension lights . . . tripods . . . exposure meters. I haven't got the time for gadgets because all my energy is concentrated on the drama which is taking place before my eyes. Some photographers would be horrified to learn that I use the much denounced flat flash (flash synchronizer attached to the camera) but I get snappy prints by using No. 3 enlarging paper.

If you are puzzled about the kind of camera to buy, get a Speed Graphic . . . for two reasons . . . it is a good camera and moreover, it is standard equipment for all press photographers . . . with a camera like that the cops will assume that you belong on the scene and will let you get beyond the police lines. (Later after you have sold some pictures, the editors will help you to get a press card.) If you come across a story, don't lose your head . . . as a rule you will be able to get close enough. The newspaper photographers don't stick their cards in their hats . . . that's only done in the movies. Just go about taking pictures without getting in anyone's way.

Don't be afraid to ask questions of cops and firemen . . . and at fires, be careful not to trip over hose lines strung along the streets. Cops and firemen sometimes like to steal a smoke, but if the camera catches them doing it, they will be brought up on charges. When you are about to take a picture and you see them smoking, ask them to drop their cigarettes . . . they will thank you for your thoughtfulness. And at auto accidents where gasoline is spilled all over the streets, don't light a smoke yourself and throw away the lighted match . . . that's a good way to start a fire to add to the confusion.

Also on stories don't get excited and start shooting at everything in sight . . . the first thing you know you will be out of film and flash bulbs and then when something really worthwhile happens . . . you won't be able to take it. Make every shot count. Think before you shoot . . . get punch into your pictures. Don't tell people to assume a pose, because editors are smart these days and they can't be fooled. People are so wonderful that a photographer has only to wait for that breathless moment to capture what he wants on film . . . and when that split second of time is gone, it's dead and can never be brought back.

Whenever I have talked before camera clubs, people have asked questions of me . . . questions like these. Who "ghosted" the stories which are published along with my pictures in this book? No one. I have written every word in this book (except for the Introduction) just as I have taken all the pictures. It's not hard. What I see and feel deeply I photograph and then I write down what I have noticed and felt. I had never done any writing until the editor of *PM*, Ralph Ingersoll, heard me wisecracking at the city desk about a story I had shot and asked me to give him some copy to go with the pictures. At first I was scared, but I sat down to a

typewriter and finally found words for what I had seen and felt. That's all there was to it.

People frequently ask about scoops and how they should be handled. Should the photographer have an agent handle the pictures or should he sell to the newspapers direct? On a scoop . . . something newsworthy, really big . . . it's best to develop about six prints and make the rounds of the local papers. Then contact a big agent like Acme News Pictures at 461 Eighth Avenue, New York. They have offices in most big cities, but make sure they get the pictures fast. They pay well for photos of news of national interest and they are also interested in features. Be sure to mail them your negatives. They are reliable and will always treat a photographer fairly and squarely.

People also ask me if contact prints are big enough for reproduction in newspapers and magazines. The answer is that they are too small and worthless . . . 5x7 enlargements will do but the best size is 8x10 . . . glossy prints of course.

Beginners want to know who owns the rights to pictures which are developed and printed by a newspaper when a photographer has no facilities of his own . . . and they also want to know what price to ask for their work. No matter who develops your pictures they are still your property to do with as you please unless they have been specifically sold for exclusive use. As for price, the sky can be the limit, but $5.00 is the usual price for ordinary pictures not sold for exclusive use. After dealing with editors for a while, the photographer begins to know what his pictures are worth in different markets. The magazines, in general, pay from $25 to $50 a page.

The problems of obtaining permissions and releases often baffle the beginner, especially when they involve accident

or rescue stories and where the pictures include policemen and firemen. On news stories neither permissions nor releases are needed except when photographs are used to advertise commercial products. Pictures of houses and buildings can be published without the consent of the owner, but if a man objects to your taking a picture of his property, he can order you and your camera off it—that's trespassing—but he cannot stop you from taking a picture providing that you are standing on a street or sidewalk which is public property and belongs to everyone.

Many times I have been asked how one goes about getting a police radio for a car and whether or not cops will reveal the code they use to transmit messages. Anyone can have in his own home a radio which will bring in police signals, but an automobile set can only be used with the permission of the police. Photographers should talk the matter over with local authorities, and once permission has been granted, the cops will cooperate and give out their code signals or any other information necessary to get to a story quickly.

There is one last question which really needs no answer, but I hear it again and again. What pull does one need to be able to sell pictures? You don't need any. Editors buy pictures on their merit and their timeliness. You can best approach the problem of selling your work by studying the papers and magazines to see how other photographers handle any given story. Figure out how you would have covered it yourself. Remember . . . the field is wide open. Be original and develop your own style, but don't forget above anything and everything else . . . be human . . . think . . . feel. When you find yourself beginning to feel a bond between yourself and the people you photograph, when you laugh and cry with their laughter and tears, you will know you are on the right track. . . . Good luck.

Other titles of interest

WALKER EVANS
Photographs for the Farm Security Administration, 1935–1938
552 photos
80008-X $18.95

ARDENT SPIRITS
The Rise and Fall of Prohibition
John Kobler
416 pp., 55 illus.
80512-X $14.95

THE BIG BANKROLL
The Life and Times of Arnold Rothstein
Leo Katcher
389 pp., 17 photos
80565-0 $14.95

THE LUCIANO STORY
Sid Feder and Joachim Joesten
336 pp.
80592-8 $14.95

WORLD ENCYCLOPEDIA OF ORGANIZED CRIME
Jay Robert Nash
634 pp., over 800 illus.
80535-9 $25.00

CAPONE
The Life and World of Al Capone
John Kobler
431 pp., 72 photos
80499-9 $15.95

I, WILLIE SUTTON
Quentin Reynolds
284 pp., 4 photos
80510-3 $13.95

KILL THE DUTCHMAN!
The Story of Dutch Schultz
Paul Sann
New preface by Pete Hamill
347 pp., 57 illus.
80452-2 $13.95

MURDER, INC.
The Story of the Syndicate
Burton B. Turkus and Sid Feder
512 pp.
80475-1 $15.95

WEEGEE'S PEOPLE
Weegee (Arthur Fellig)
242 pp., 229 photos
80242-2 $13.95